Ilkley
—AND THE—
GREAT WAR

Ilkley
–AND THE–
GREAT WAR

Caroline Brown & Mark Hunnebell

AMBERLEY

First published 2014

Amberley Publishing
The Hill, Stroud
Gloucestershire, GL5 4EP

www.amberley-books.com

British Library Cataloguing in Publication Data.
A catalogue record for this book is available from the British Library.

ISBN 978 1 4456 4102 7 (print)
ISBN 978 1 4456 4111 9 (ebook)

Typesetting and Origination by Amberley Publishing.
Printed in Great Britain.

CONTENTS

ACKNOWLEDGEMENTS

Many people have contributed to this book in recording, preserving and providing material from a variety of sources over many years.

Special thanks are due to Sally Gunton for giving generous access to her extensive collection of local images, and to John Davies for proofreading and giving valued assistance with digital imaging. The *Ilkley Gazette* has been invaluable as a source of information and historical detail. Many thanks go to the staff of the newspaper for granting access to the newspaper's archives.

Thank you to Anthony Hughes and the staff of WYAS Bradford for assistance and access to archives, and the archivists of the Liddle Collection at Leeds University Library for permission to reproduce items from their archives. Thanks go to Maggie Horsman and the helpful staff at Ilkley Library, and to Patrick Anderson who provided useful information about the Scottish contingent and their training camp in Ilkley. Finally, thank you to Jeff Pancott and Alison Harrison at Ilkley Grammar School for sowing the seed of the idea for this book through a project to commemorate the centenary of the First World War, and to Elizabeth Watts at Amberley.

A wide variety of sources and original documents have been consulted, including newspapers, letters, diaries, postcards, plans, drawings, journals, pamphlets, memorabilia and committee minutes, in researching a complex period of history. While every effort has been made to trace permissions for reproducing material, as well as to the accuracy of the information in the book, the authors hope that readers will ale

INTRODUCTION

The worldwide unrest of the First World War changed all aspects of life. It was the first total war. Everybody was to be affected through changing circumstances, absence or loss of loved ones, and for those serving overseas there were harrowing experiences beyond anything known before. The repercussions were felt across cities, towns and villages across the world.

As we mark the centenary of the First World War, while remembering those who died serving their country, we recognise also the impact the war had on those at home and on those who returned. Ilkley's citizens all played their part during the First World War. A surge of patriotism led to a massive voluntary effort both at home and abroad. While Ilkley was not an industrial centre and not associated with munitions work, there was a massive rise in the hospitality trade in the early part of the century. The town was transformed from a genteel spa to a military town with an influx of officers and cadets to local billets and to training camps on fields near the River Wharfe. Many of the grand hydros and hotels had been adapted for new purposes. Belgian refugees arrived and sick and wounded soldiers were treated in the military hospitals.

While those at home worked to support the war effort and faced the challenges on the home front, men from Wharfedale served in all of the major battles on the Western Front as well as in theatres of war around the world. In addition to France and Flanders, parcels from Ilkley were sent to Russia, Egypt, Mesopotamia, Greece, India, South Africa and Malta, as well as prisoners of war stationed in Germany and Turkey.

Letters, diaries and poetry, as well as visual records, photographs, postcards, sketches and memorabilia, show how closely the experiences of those serving overseas are interlinked with those at home, through memories and support from home and the strong *esprit de corps* that came from serving with those from the same community.

At the outbreak of war, Ilkley had developed its character as a Victorian inland-spa resort and as a residential town for businessmen from Leeds and Bradford. The arrival of the railway and the sale of land by the Middleton family were key factors in Ilkley's rapid development. Rail connections with Bradford and Leeds had been established in 1865, and by 1888 trains were running from Ilkley to Skipton. It was a time of civic pride. The King's Hall had opened in 1908 along with the town hall and the library

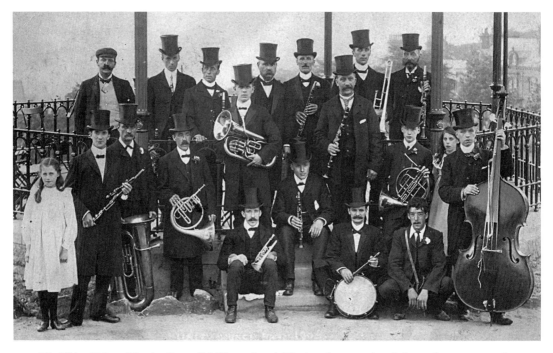

The Ilkley Urban District Council Military Band. The band gave twice-daily performances at the Winter Gardens during the holiday season when the weather was inclement. On fair weather days, the band played at the bandstand on West View Park.

and was widely used for plays, concerts, meetings and exhibitions. However, it was realised that to keep pace with other resort towns a hall was required with open access to the public. The Winter Gardens opened in June 1914 to fulfil this need.

Throughout the war, Ilkley remained a resort town, both as a fashionable destination for the middle classes staying in the hotels that followed in the wake of the hydros and as a destination for visitors from the manufacturing towns of Yorkshire and Lancashire – many of them munitions and textile workers.

In 1872, however, Ilkley came very close to developing in a very different way – as a major military base. The latter part of the nineteenth century was a time of military expansion with countries around the world seeking power. To keep pace with the growth of militarism, the War Office had the task of establishing a tactical training station for the army in the north of England.

A 6-mile stretch of moorland from Ilkley to Bingley had been identified as a potential site for the extensive army camp due to its central location for both the east and west coasts, as well as the good railway links on both the Airedale and Wharfedale sides. The Leeds & Liverpool canal network was also a key factor. Harry Speight recorded the following in his book *Upper Wharfedale*, published in 1900:

A canal wharf for cannon and war material was to have been made between Bingley and Morton and nine stations erected within five miles of the moor, to which troops

could be simultaneously marched, and 100,000 men, horses, cannon, etc., could be dispatched to Barrow, for Ireland, or to any other part of England within twenty-four hours. It was to have been a great depot for war material, and permanent barracks for two regiments of infantry and one regiment of cavalry. It was intended to camp 60,000 to 80,000 on the moor every summer.

From the start, there was considerable local opposition to the proposal. Arguments against the plan ranged from the impact on grouse shooting to the effect on the Ilkley tourist trade. A letter printed in the *Bradford Observer* early in 1873 said,

> People who were in the habit of going there for convalescence, enjoyment or repose, would find it anything but a congenial thing to have the moor made the scene of mimic warfare, and perhaps to discover while they were out walking that they were in the way of a troop or a cavalry.

A further argument concerning the wider and moral implications of building military capacity was put forward by Ilkley businessman Mr Dymond at a public meeting at the Wheat Sheaf Inn: '... a standing army was a reproach to civilisation of the nineteenth century'. Eventually, after much deliberation and a visit in May 1873 from the Duke of Cambridge, Commander-in-Chief of the Forces, the plan was scrapped. The difficulties with the site were primarily due to the terrain and the altitude of the moor. In 1884, 1,800 acres of Strensall Common near York were purchased by the War Office for the formation of a camp for training troops.

International tensions continued to rise, and military conflict came to the east coast in 1904 when Hull trawlers on the Dogger Bank were shelled by the Czarist Navy who mistook them for Japanese torpedo boats, triggering calls for a war with Russia. In national politics, the young Independent Labour Party (ILP) was taking on both of its established opponents – the Liberals and the Tories. The ILP's inaugural conference had been held at the Bradford Labour Institute in 1893. Over a third of the 120 delegates had come from Yorkshire's woollen districts. Bradford had a tradition of close commercial links with Germany dating back to the 1820s, when many Germans came to build businesses or to work in the textile industry. They became closely integrated with the culture of the city and the district. A strong trade was formed in exporting woollen goods from Bradford to Europe. Many of Ilkley's prominent residents were merchants and manufacturers who had business interests with Germany within the wool trade, and many people connected with the textile trade visited Ilkley for leisure purposes.

However, despite these national and international tensions, on a local level the early years of the century were characterized by a pace of life that reflected the past rather than the future of world conflict that lay ahead.

Norman Tennant from Ilkley, who served with the 11th West Riding Howitzer Battery, kept detailed diaries of his experiences on the Western Front. He described nostalgic memories of pre-war life from his father's boot and shoemaker's shop at No. 6 Wells Road:

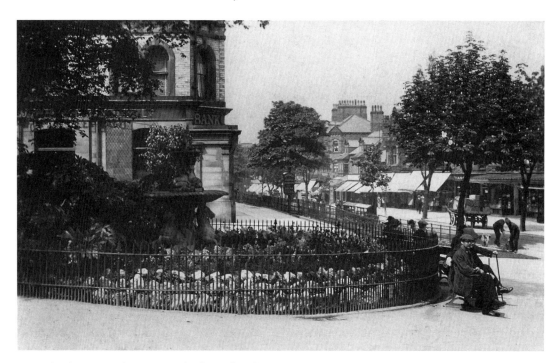

The decorative fountain at the foot of Wells Road *c.* 1915. This was a popular spot for people to sit and watch the town go by. Water flowed from the nostrils of four horses, and it was decorated at the top with mermaids and serpents. Water for the fountain came from Mill Ghyll.

To me, the atmosphere of those pre-1914 days can be brought to mind by the memory of the gentle splashing of a public fountain opposite my parents house and the quiet murmur of the beck which supplied it, before running down the street to the river. It was a refreshing sound during the long hot days of summer in a quietness and secure peace now, alas, unknown, and the occasional clip-clop of horse carriages did nothing to disturb the calm. Winter with six or eight inches of snow on the ground could be even quieter, since road traffic was either muted or stopped altogether and the only sounds were the scrape of shovels as men tried to clear the roads and footpaths. It was such indications as these of the leisurely tempo of life which heralded the worldwide unrest of the early years of the century and brought the reality of war into clearer perspective.

CHAPTER 1

AT WAR

'We moved from peace to war in the space of a single night's experience. Who slept in the night of August 4th awoke the next morning to war.'

In 1920, Laurie Magnus thus described the experience of the declaration of war in his book, *The Story of the West Riding Territorials in the Great War.*

> No one in the present generation is likely to forget Tuesday August 4th, 1914. A greater complexity of emotions was crowded into the twenty-four hours which ended at 11 pm (midnight by mid-European time) that day than was known before or has been known since.

Announcing the news of the declaration of war, the *Ilkley Gazette* focused on the events leading up to it: 'The danger which loomed when Austria and Serbia came into conflict has materialised ... The *casus belli* is Germany's refusal to guarantee that she would not outrage Europe by violating Belgium's neutrality.'

The assassination of Archduke Franz Ferdinand of the Austrian-Hungarian Empire in the Serbian city of Sarajevo on 28 June 1914 had contributed to a chain of events that led to war. During the decades before 1914, the most powerful nations in Europe had split into two rival groups. Germany had united with the Austrian-Hungarian Empire to form the alliance known as the Central Powers in 1882. To counterbalance Germany's growing power, Britain, France and Russia formed the 'Triple Entente' and later fought together as the Allied Powers. Russia was the Serbs' principal ally. Within six weeks of the assassination of Franz Ferdinand, Europe was at war. On 2 August 1914, a German ultimatum was delivered to Belgium requesting free passage for the German Army on the way to France. King Albert of Belgium refused the request. The prospect of Germany violating Belgium's neutrality and destroying France as a power had led to the increasing acceptance that Britain would be forced to intervene. The days immediately before and after the declaration of war were marked by swift action and a thirst for news delivered across the country in the morning newspapers.

In Ilkley, Mr Dobson, the chairman of the council, ran the newsagents on Brook Street. On the Sunday before the outbreak of war, 'yielding eventually to considerable

pressure', Mr Dobson opened his premises and posted news of the crisis in his shop window. *The Ilkley Free Press and Addingham Courier* described the scene:

A steadily growing crowd stayed to read the notice. After the concert in the Kings Hall concluded, the numbers were still further swollen, reaching almost across the roadway …Then the special editions came in. There was a mad rush for the shop. The plate-glass windows creaked dangerously. Mr Dobson's son came out with a bundle of papers and was very nigh mobbed. Penny papers were sold for two-pence and three-pence each. The news was eagerly devoured, and even though the hour was late, people seemed in no hurry to make their way home, but remained in excited groups animatedly discussing the situation.

By Tuesday evening, this crowd was surpassed in numbers and excitement. News of the declaration of war was expected at about midnight and, by this time, the whole of the top of the street was filled. When the news was announced shortly after midnight to the waiting crowd, *The Ilkley Free Press* reported that rousing cheers were given for the King and the national anthem was sung.

The following morning, 'At War!' was the headline in *The Yorkshire Post*. 'These fateful words were flashed last night to all our forces in all parts of the empire and to all our fleets – already cleared for action.' The first lead article in *The Yorkshire Post* drew attention to

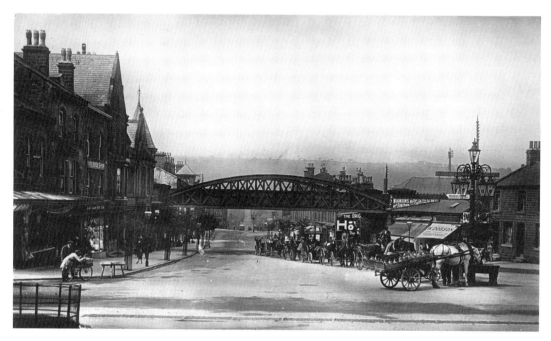

Brook Street *c.* 1913. William Dobson's newsagent, on the right of the picture, attracted a large crowd as the news of the outbreak of war was declared. Horse-drawn cabs wait down the centre. The ornamental lamp post in the foreground was the regular focus of night time revelries by school-leavers and officers at the pre-war training camps.

the advances in science and technology that had contributed to the preparations for war. It regretted the breakdown of efforts towards international understanding, but stated that 'there are times and conditions in which peace is impossible'.

At this stage, the war was seen pre-eminently as a naval conflict. The Germans, with a large conscripted army, had little to fear from the small British Army, which was more used to fighting colonial campaigns within its empire. On 7 August 1914, the *Ilkley Gazette* gave a good indication of the relative strength of the land armies involved in the conflict:

> Great Britain: Regular army 162,000. Total war strength including reserves and territorials: 724,000
> Germany: 2,750,000
> France: 2,750,000
> Russia: *c.* 3 million
> Austria: 1,300,000
> Serbia: *c.* 450,000
> Montenegro: 40,000
> Belgium: *c.* 200,000
> Holland: *c.* 150,000

Immediately after the declaration of war, there was a mad scramble to stock up on provisions, forcing prices up. *The Ilkley Free Press* reported that the price of flour had jumped from 1s 8d per stone to 2s 4d. Sugar, butter, eggs, bacon and cheese were all similarly affected: 'Perhaps more than in any other direction is the real meaning of war brought home to the everyday life of the people by the tremendous increase in the price of food.'

Shortly after the declaration of war, an embarrassing incident was reported in the *Ilkley Gazette* when a local cyclist inadvertently flew a German flag from the handlebars of his bicycle:

> An Ilkley cyclist the other day was anxious to do honour to 'Gallant Little Belgium', and with this object he purchased what he was led to believe was a Belgian flag, though he had not proceeded far with this emblem of nationality attached to his handlebar fluttering in the breeze, ere he was pulled up and attention drawn to the fact that he was showing disloyalty to the English throne and constitution by displaying a German flag. He had to plead ignorance and explain the circumstances, otherwise he might have been roughly handled – a result, which in some places, would have very speedily followed.

The declaration of war had arrived during the holiday season. After the initial cheering for the King, *The Ilkley Free Press* described a new mood that had settled on the town:

THE BEST SILK AND LINEN
UNION JACKS
AND OTHER FLAGS,
SUITABLE FOR MOTOR CARS & BICYCLES
ARE NOW IN STOCK at
Shuttleworths' Fancy Stores
BROOK ST., ILKLEY.

Flags are on sale at Shuttleworth's shop at Gothic House on Brook Street. John Shuttleworth had set up a gift-selling business in the latter part of the nineteenth century selling 'fancy goods', guides and postcards. He had established the *Ilkley Gazette* in 1861. After his death in 1909, the newspaper continued to be published by two of his sons – Charles and Ernest Shuttleworth.

The grim shadow of the war has hung over the whole of the Bank Holiday celebrations at Ilkley. On Saturday when the shadows were gathering, there was a fairly large number of people in the town. The hydros and hotels were crowded, and the day trippers were many. But Monday, with the discontinuation of the North Eastern excursions, brought relatively few day visitors and even at the merriment loving hydro, visitors there brooded that which dulled the edge of holiday pleasures, and made even holiday laughter take an unusual ring.

The first editorial of Ilkley Grammar School's magazine, the *Olicanian*, following the outbreak of war in winter 1914 captured the sense of gravity that prevailed:

So much has been written in the public press and elsewhere of the reasons why Great Britain has taken up arms in this, the most gigantic and terrible war of all times, that it would serve no useful purpose to reiterate those reasons. It will be sufficient perhaps if we confine ourselves to stating briefly how we have been affected and what share we are taking in our country's hour of need.

However, despite this mood, the war unleashed a patriotic fervour that had been building during the reign of Queen Victoria. In 1957 in his book on the history of Ilkley Grammar School, Norman Salmon wrote, 'It is difficult for those who have not lived through those times to understand the spirit of the nation then.'

The South African War had contributed to a spirit of active patriotism. An enthusiastic send-off had been given to the reservists in 1899 and later in 1901 to men from the Ilkley Volunteers who went to fight. Following the news of the relief of Mafeking in 1902, the *Ilkley Gazette* reported that the people of Ilkley were awakened

by the sound of church bells, shots and rockets. A large crowd gathered in the streets; the celebrations went on all day and the Ilkley brass band played until after midnight.

However, before the end of the South African War was in sight, Queen Victoria had died in January 1901. In 1908, to boost the imperialist spirit, the British Government announced that the 24th of May, Queen Victoria's birthday, would be termed 'Empire Day'. In recognition of this, flags were raised from buildings in Ilkley, including the Constitutional Club, Wells House and the grammar school.

At the grammar school, proceedings for Empire Day each year included the singing of 'Land of Hope and Glory' – responsibility, duty, sympathy and self-sacrifice were emphasised as watchwords.

Following the South African War, there had been increased development work on a national scale with regard to physical fitness, fieldcraft and drill. This war had focused on the fact that, while the Boer fighters were skilled in the use of the rifle, the average British soldier was not trained to be a marksman. Instruction in the use of the rifle and physical training of a military character in the curriculum of all boys' schools was advocated by Lord Roberts, commander of the British Army in South Africa, and supported by the British Government.

The grammar school embraced the spirit of the times with a rifle range built at the lower end of the field where Coronation Hospital now stands. In 1903, the strip of land was sold for the hospital development, but the rifle club continued in the school gymnasium for miniature rifle shooting. Later, they continued at a range on Easby

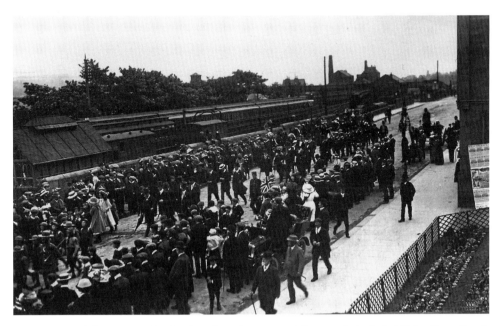

Coronation celebrations in Station Road, 22 June 1911. The parade included Ilkley Brass Band, Boy Scouts and officials. The railway sidings and goods yard, along with the cabman's shelter, is on the left. The garden at the right was replaced by the Winter Gardens in 1913. In the distance, the chimney of the brewery can be seen.

Drive, opened by the Ilkley Rifle Club. The club granted free use of their rifles to all of those who wanted to learn to shoot. The president of the club, Mr Frederick Broadbent Maufe, donated £5 towards providing ammunition, with further donations coming from other members. A prominent supporter of the national drive to create miniature rifle ranges was Baden Powell, who visited the Ilkley range in 1905 and presented the club prizes.

Despite these military endeavours, the regular army at that time was a relatively small force, supplemented by companies of volunteers. The Ilkley Company of Royal Engineer Volunteers had been established in March 1899 as a detachment of the 2nd West Yorkshire Royal Engineer Volunteer Battalion. The company maintained a membership of around 100. The Ilkley College was the base for the Ilkley Volunteers from 1899 until 1902 as an armoury and for drill practice. In 1902, a shop in the Arcade on the right was secured as an armoury for the Ilkley Volunteers. Drill took place at the Pleasure Gardens next to the river off Bridge Lane. By 1908, the Ilkley Volunteers had an armoury premises in Cunliffe Road.

It was here that the men assembled in late February to hear how the company would be affected by proposals under the Territorial and Reserve Forces Act as part of Sir Richard Haldane's army reforms. The *Ilkley Gazette* reported that efforts were made to 'obtain a position as a wireless telegraphy company'. Radio telegraph communication was in its infancy at the time, and the Ilkley Volunteers clearly wanted to be at the forefront of what was then innovative technology. However, the county association and the army council decided that the Ilkley Company would become a territorial

The Ilkley College opened in 1869 as a school for boys. It was the base for the Ilkley Volunteers from 1899 until 1902 as an armoury and for drill practice. In 1902, the Wesleyan Deaconess Order had taken over the building to train women to work with the Methodist church.

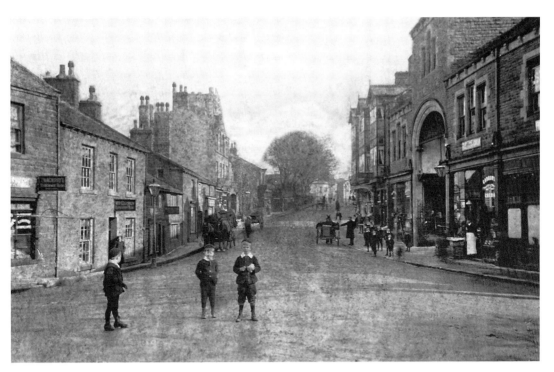

Church Street. In 1902, a shop in the arcade on the right was secured as an armoury for the Ilkley Volunteers. Drill took place at the Pleasure Gardens next to the river off Bridge Lane.

By 1908, the volunteers had an armoury premises in Cunliffe Road.

force – the 4th West Yorkshire (Howitzer) Brigade, Royal Field Artillery. Initially, only twenty-seven men transferred from the former Ilkley Company, although new recruits joined.

Towards the end of 1910, construction began on the territorial Drill Hall, a permanent base for the Ilkley Company. This was situated on Leeds Road on land adjacent to the gasworks. On the ground floor of the building was a drill hall of 60 feet by 30 feet, a wagon shed, lecture room and bar, armoury, orderly room, harness room and a house for the instructor. On the first floor was an officers' room, quartermaster's stores, NCO room and bar. The Drill Hall was built from local stone at a total cost estimated at £1,800. Albert Kirk of Leeds was the architect and the builders were Horner and Maud of Horsforth.

Before the war, the old 5-inch Howitzers had been housed in the Drill Hall for training. These BL (breech loading) guns had been used in the South African War and later went to France with the Ilkley and Otley Territorials. They remained with the unit until January 1916 when they were replaced by QF (quick firing) 4.5-inch Howitzers, severing a strong link with pre-war days. Cpl A. E. Gee wrote, in *A Record of D245 Battery, 1914–1919*:

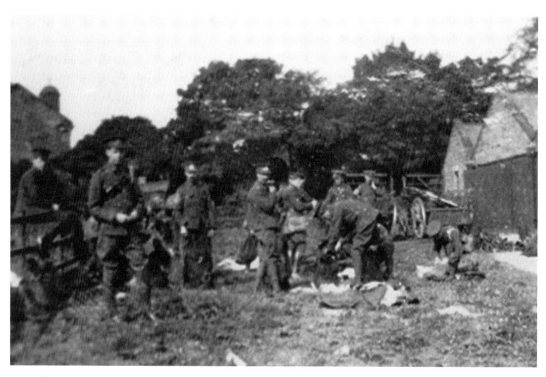

The Territorial Unit are packing up their equipment at the back of the Drill Hall, which opened at the end of November 1911 and served the military interest of the town through both world wars. In the Second World War, it was a base for the local Home Guard.

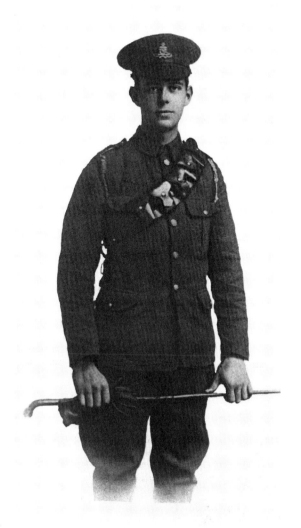

Norman Tennant in 1913, shortly after enlisting in the Ilkley Territorial Unit at the age of seventeen. The outbreak of war interrupted his studies at Bradford Art School. In his diaries and sketchbooks, he documented the story of the Ilkley Territorials throughout the war and as a signaller: '... the bitter frustrations of laying and maintaining, in impossible conditions, the miles of telephone cables on the Western Front'.

It seemed rather hard at first to lose our dear, dirty old guns, which had been with us all the time. They had indeed, lived in the Ilkley Drill Hall for years before the war, and all the old gunners of the Battery had learned their drill on them. In the war, they had already fired thousands of rounds at the Boche, and had done yeoman service. However, once sentiment faded, the new weapons were keenly studied, and the attraction of the 'Quick Firing' part of their title was powerful.

By the end of the war, the Territorial Force had become 'a band of well-seasoned old soldiers, who, though in many cases young in years, had three-and-a-half years of active service to their credit'. (A. E. Gee)

However, before the war, many of the members of the local Territorial Army unit had joined straight from school and trained at the Drill Hall on Saturday nights and

at weekends and annual summer camps. One of these 'Saturday night soldiers', as they were known then, was Gunner Norman Tennant who later recalled in his diaries training there in the use of the rifle and the 5-inch Howitzer guns:

> Together with some of my school friends who had just left the Grammar School at Ilkley, I enlisted, under the legal age, in the local Territorial Army unit ... To the great dismay of my parents I arrived home one evening with a kit-bag full of uniforms and equipment, in pocket to the sum of one shilling, 'the King's shilling' ... On Saturday nights we were trained at the local drill hall in the use of the rifle and the 5 inch howitzer, together with the painful acquisition of a precarious seat in the saddle on a wide variety of horses hired from the local tradesmen.

For the younger boys still at school, in the hot summer of 1914, a Junior Cadet Corps had been formed at the grammar school, learning fieldcraft in attack and defence on the moors and parading under the leadership of the headmaster Mr Atkinson, Mr Downing and Sgt Baker.

At this time, Ilkley Grammar School was a fee paying school. Most of the boys came from Ilkley, Ben Rhydding, Burley and Otley with a limited number of scholarships. There was fierce competition with private schools. Many of the larger of these had their own junior contingents of the Officer Training Corps. However, Mr Atkinson's repeated efforts to establish an Officer Training Corps within the school were turned down by the War Office for the duration of the war.

During the war years, the boys of the upper school paraded for voluntary drill after school. However, by spring 1918, partly due to the influenza pandemic, enthusiasm had waned as the school magazine records:

> The work of the School Cadet Corps has been seriously hampered this term by the large number of absentees, but even allowing for this the progress made can hardly be regarded as satisfactory…Those boys who seem to resent orders given to them should remember that those who wish to command must learn to obey. One parade a week can hardly cause strain from overwork.

CHAPTER 2

IN THE BEGINNING

Immediately after the outbreak of war, Ilkley reservists left to join their regiments. Many were in public service positions, such as Police Constable Jubb. Some were working at the post office or at the railway station. Men from the Yorkshire Hussars were given a rousing farewell as they left to join their regiment.

On 30 October 1914, the first Ilkley detachment of the West Riding Clearing Hospital left Leeds for Southampton. The following evening, the unit embarked on the hospital ship *St Andrew* (which was later sunk). Their duties were to follow the moving army and to take the wounded from the field ambulance to treat the cases that could be sent back to the front within a day or two and remove the remainder to the base.

When war was declared, the Ilkley Territorial Unit had only recently left for their annual fortnight's summer camp at Pembrey in South Wales, with the other units of the 49th West Riding Division. After just one night under canvas, all units were given emergency orders to return immediately to their home base, and the guns and wagons were loaded back on to the trucks. The train returned to Ilkley in the early hours of Tuesday 4 August 1914. All units were mobilised for full time war service on 5 August 1914.

Orders were given to the Territorial units to report immediately at the Drill Hall in marching order. Gunner Norman Tennant later recalled the experience: 'When my embodiment notice arrived by post the following day, I felt we were irrevocably committed to the unknown.'

By noon, all the men had reported at the Drill Hall, and after packing the guns and wagons once again, they were given identity discs with names, numbers and units in preparation for a move to the mobilisation centre at Brigade HQ at Otley the following day. For this, a six-horse team was needed to pull the four guns and limbers.

From 4 August 1914, the Army Act allowed the requisition of animals as well as carriages, vessels and aircraft. Four of Ilkley Council's horses were commandeered by the War Office soon after the outbreak of war, as well as a water wagon from the highways department, leaving three horses with the council. A sum of £254 was received by the council from the War Office. However, at the time of receiving mobilisation orders, the unit had no horses. Cpl A. E. Gee described how the problem was solved in the record of the D245 Battery:

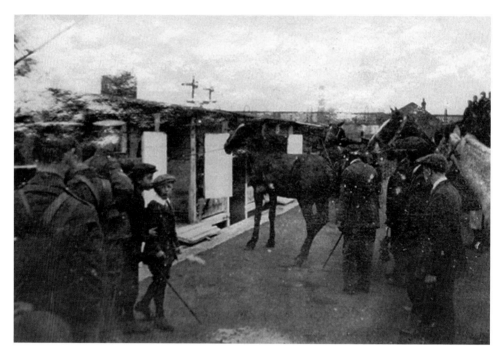

The Ilkley Territorial Unit – the 11th West Riding Howitzer Battery – load the horses onto the 'troop-train' at Ilkley railway station for their annual camp in Pembrey, South Wales. The men travelled at the front of the train, the horses in boxes at the end of the train in front of the guns.

> The problem was finally solved … two of the Urban Council's steam road rollers came puffing down the street at a steady three knots, and before long, each at the head of two guns and four wagons lashed to one another, the Battery was sailing under steam down the road to Otley. It took a long, long time to cover the six miles, and we must have looked like a couple of convoys of Thames barges in charge of steam tugs; but we got there.

Along the way, the Ilkley men were joined by the Burley contingent. The Otley and Ilkley Units, the 10th and 11th West Riding Howitzer Batteries and RFA, together with the 4th Ammunition Column recruited from Burley, made up the Brigade.

Over the following days, new recruits were taken on and mobilisation stores were issued. Gun drill and riding drill commenced as horses were acquired. On 10 August 1914, the Brigade marched from Otley to join the rest of the 49th West Riding Division in Doncaster.

> It was a great day. Otley seemed en fete; crowds lined the streets and all ranks must have felt great fellows. True, the horsemanship was a bit ragged, but most of the horses were new to it all. However, the Brigade was completely equipped, and with its eight 5-inch Howitzers and many Ammunition Wagons, all drawn by six-horse teams, it must have presented a stirring spectacle to the crowd, who were

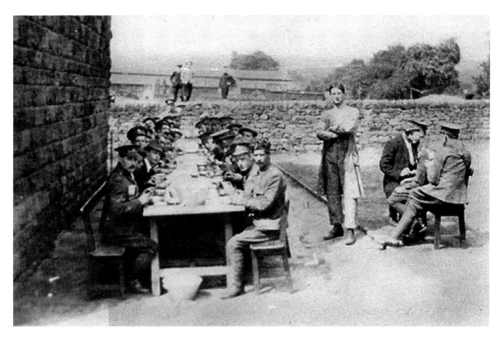

Immediately after the outbreak of war, the Ilkley Territorial Unit were ordered to move to the Brigade HQ at Otley where they were billeted in the school at Cross Green. This photograph was by Norman Tennant and is captioned 'meals in the school playground'.

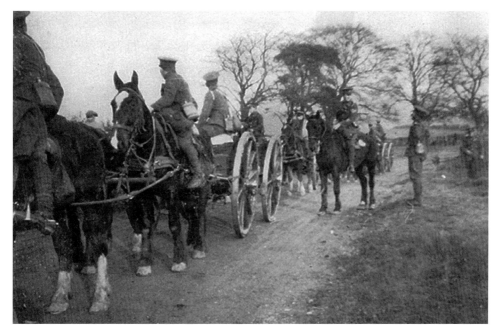

'The Great North Road' is Norman Tennant's caption for this informal picture of the Territorials en route to Doncaster to join the rest of the West Riding Territorial Division in August 1914. The Brigade marched via Leeds and Pontefract.

by now, wildly enthusiastic about anything and everything of a military nature. (A. E. Gee)

At this time, it was widely believed that the Territorial Units would be assisting in the defence of the East Coast. The enthusiastic send-off was repeated all over the country, including other local headquarters such as Guiseley, Yeadon and Rawdon. The Brigade marched via Leeds where they stayed at the old Carlton Barracks and Pontefract, where they were billeted at an ice rink.

In the early evening of 12 August, the Brigade reached their new home at Doncaster racecourse where they would be in training for the next eight months. The guns and wagons were parked in the large square at the rear of the grandstand. After some initial upheavals, the Brigade's personnel were billeted in the grandstand. Each sub-section had a large 'airy' room with wooden floors and a fire grate, and the horses were kept in the stables.

Soon after their arrival in Doncaster, volunteers were invited for service out of the country. The Territorial Attestation from 1908 was for service within the UK only; however, 'The battery volunteered almost to a man for overseas', wrote A. E. Gee. Laurie Magnus, in his book *The West Riding Territorials in the Great War*, states that, in total, over 30,000 recruits were taken by the West Riding Territorial Force Association between the date of the outbreak of war and 14 April 1915. Of all of the West Riding Territorials, it was estimated that a few weeks after mobilisation, the complete total of volunteers for foreign service was around 96 per cent. By volunteering freely for overseas service, the pre-war Territorials enabled the necessary reinforcements for the reservist army in the field to be maintained, while Kitchener's 'New Army' was in the making.

In September, in the wartime spirit of 'business as usual', the Brigade moved to camp at Sandbeck Park near Rotherham for twelve days, to enable the St Leger to be held at Doncaster racecourse. Duties included 'morning stables' at 7.15 a.m. and guard duty over the Brigade's vehicles. Training included developing skills in riding as well as battery and brigade drill. Field days with the rest of the 49th West Riding Division were held in the surrounding countryside. Following the day's exertions, the theatre in Doncaster was a popular form of evening entertainment:

Patriotic songs were showered on the khaki audience, all of which ditties seemed to express the hope that we should soon march out, and soon march back. We weren't too sure of doing either, as a matter of fact. (A. E. Gee)

Weekend leave was granted on a rota basis. In the outer hall of Ilkley station, large crowds assembled regularly to see off the returning train on Sunday evening. A. E. Gee stated:

Every departing soldier got a send-off such as he would have got had he been going off straight to the Front. Probably the majority of the crowd thought this was the fact. After two or three such send-offs, this business got a bit disturbing, making the victim

feel that he really was deceiving them all. However, that was put right in time, and later on, many of the crowd became, in their turn, departing soldiers.

Early in 1915, the training became intensified:

> Rumours of the probable destination of the Division were prevalent with the Western Front as a hot favourite but India a distinct possibility. It seemed queer to have all manner of foreign places calmly discussed by those who, almost to a man had never crossed the Channel before.

In March 1915, final leave was given. After dark on 14 April 1915, the Brigade left Doncaster for the last time by train to Southampton, bound for an unknown destination. The guns, horses and baggage were transferred to the SS *Anglo-Canadian*. The following night, the ship quietly glided away from harbour for Le Havre; 'weather clear, no wind' was recorded in the log.

Some veterans of the South African War who went to Doncaster with the territorials did not go with them to France, but stayed behind to train new recruits. When the unit left for France with the 49th West Riding Division, the 4th West Riding Brigade numbered 9 officers and 180 men of other ranks. The average age of the battery personnel when they went overseas was under twenty-one. The minimum enlisting age was then nineteen. Several with some amount of service went across at below that age. The *Ilkley Gazette* reported on their departure:

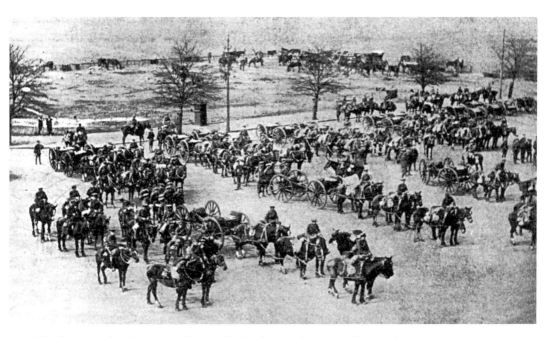

The final parade of the whole Brigade before leaving Doncaster for Southampton.

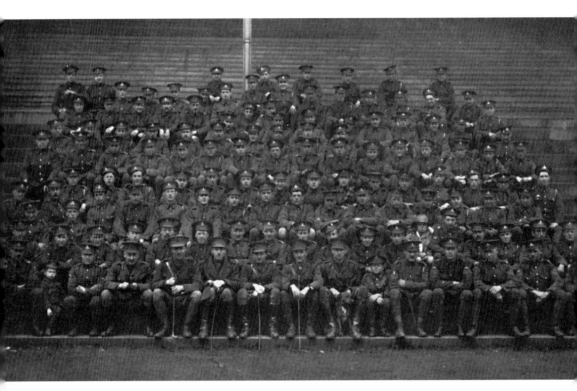

11th (Ilkley) West Riding Battery, Royal Field Artillery at Doncaster, April 1915. The Brigade sailed for France on the night of 15 April 1915.

Yesterday the men of the 4th West Riding Howitzer Brigade, Royal Field Artillery, who for some months have been under training at Doncaster, left for a destination unknown; an expression supposed to convey nothing definite, but significant and sorrowful enough in all conscience for those amongst us who are parting with those near and dear to them; probably for the last time. What lies before our men, God alone knows, and oh! How much we would like to see every one of them return equally fit and well as they were when we last saw them.

It quickly became apparent that the number of men serving in the forces was inadequate for the anticipated conflict. It was widely believed in the early stages that the war would not last long. Lord Kitchener, the Secretary of State for War, was one of the few to foresee war lasting for years. The government was reluctant to impose conscription (although it was eventually introduced in March 1916). On the outbreak of war, Lord Kitchener initiated a highly successful recruitment campaign featuring the famous poster, 'Your Country Needs You'. Patriotism was high and fuelled by stories of alleged atrocities carried out by the German forces towards the Belgians. Army recruitment offices were inundated with applicants. The demand of around 30,000 per day on a national basis meant that the Army alone couldn't cope, so local councils were used to organise the recruitment rallies.

In Ilkley, one such rally took place in the King's Hall on 31 August. The *Ilkley Gazette* reported a 'crowded and enthusiastic meeting' presided over by the chairman of the Ilkley District Council, Mr Dobson.

A united choir drawn from all the places of worship in the town, and conducted by Mr A.T. Ackroyd, led the singing of the English, French, Belgian and Russian National Anthems, and at the rear of the platform hung a large Union Jack, with emblems of warfare on either side of the proscenium, in the nature of ancient firearms, and spears and shields used by the aborigines of Africa and other countries ... Never has such a wave of patriotic fervour swept Ilkley before. The meeting was full of it, and at the conclusion, when those willing to recruit came up to the front, and finally were arranged on the platform for their names to be taken, it was the scene of the wildest enthusiasm imaginable.

As a result of the meeting, under the headline 'To Destroy Tyranny, Ilkley's Splendid Response', the *Ilkley Gazette* reported that 127 recruits had been enrolled. These men were attached to the West Riding Regiment to form the Ilkley and Addingham Company.

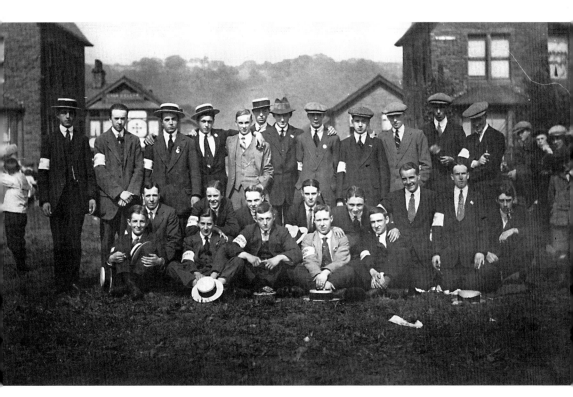

A group of Ilkley's Kitchener Recruits wearing their armbands on the field next to the Drill Hall. The houses front left and right are on Leeds Road. Behind the men is Ash Street, with houses on Ash Grove in the background.

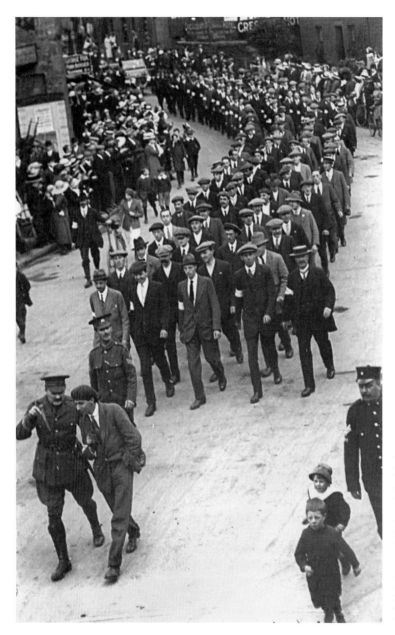

'The Pride of Ilkley on the March.' Kitchener Recruits marching out of Leeds Road to the bottom of Brook Street in September 1914. The procession is headed by Roy Cowling and Capt. E. E. Lansdale. Sgt Baker is next in the procession, and Mr F. H. Humphries brought up the rear.

The 'Kitchener Recruits' had little, if any, military experience. Following a brief period of induction, the recruits marched off from the Drill Hall for their training camp near the village of Wool in Dorset, which would be their new home until the following summer. They were given a huge send off: 'never has such a scene been witnessed at Ilkley', reported the *Ilkley Gazette*. The Ilkley Brass Band led the march. Crowds lined the streets, children waved flags and stood at the salute. A local resident composed a poem full of patriotic pride published in the *Ilkley Gazette*:

The Boys Who Marched Away

Bravo Ilkley! Bravo Ilkley!
Your name has won renown,
They heard the call –your Yorkshire sons,
To leave their moorland town.

They knew their duty, did it well,
And quick without delay, As mothers, sweethearts, waved farewell
They proudly marched away.

Bravo Ilkley! Bravo Ilkley!
Fair home of line and crag;
The birthplace of the lads who went
To rally round the flag.

Bravo Ilkley! Bravo Ilkley!
May each of them return,
And should they Wilhelm's monsters meet
Both fame and glory earn.

(S. F.)

On the first day, the men marched to Keighley Drill Hall through Addingham, Silsden and Steeton, picking up new recruits on their way. In Keighley they reported a good reception and a splendid tea. Following tea, the mayor threw open the baths to all of Kitchener's men. The next morning, the men marched to Halifax where they were given clothing and equipment. By the time they reached Halifax, two companies had been formed, each of approximately 120 men. That evening they travelled overnight by train on a twelve-hour journey from Halifax to Wool.

First reports of camp life stated that it was 'the very reverse of a bed of roses', and they had to 'rough it' considerably. However, by September 1914, a group of Ilkley and Burley men of the 1st Company Duke of Wellington Regiment wrote to the *Ilkley Gazette:*

Food and conditions generally are very good, but we have got no equipment yet. Speaking for our tent, we are all merry and bright; seeing we are far from any town … Hoping this letter will encourage the boys we have left behind for enlistment. This has been written while we are all seated round the tent.

The recruits at Wool received a visitor from Ilkley who was on his holiday in the south of England. The visitor noted that the men had enjoyed drinking at the beer canteen with their first pay packets and gave his impressions of the scene to the *Ilkley Gazette:*

All sorts of work has to be undertaken, and Mr Bradley was particularly amused to see some of the more gentlemanly young fellows washing dishes, serving food, and otherwise menially, but usefully, employed. This will prove the best experience possible for some of them, particularly the pampered youth who at home had to be waited on hand and foot.

The recruits at Wool had been dispatched to the front by the summer of 1915. In France in July 1915, many of the Ilkley Territorial Battery walked over to Vlamertinghe to see the 9th Battalion Duke of Wellington's West Riding Regiment, which had just arrived from England. Among them were the company formed of Ilkley boys from the 17th, a Kitchener's Division due to go into action at Dickbusch.

However, back in September 1914, there had been an element of rivalry between the Territorials and Kitchener's men. The photograph entitled 'The Pride of Ilkley on the March' appeared in the *Ilkley Gazette* in September 1914, showing the Kitchener Recruits marching through Ilkley to a recruitment meeting in Addingham. This picture caused some ill feeling amongst the men of the Ilkley Territorial Howitzers stationed at Doncaster, who had not enjoyed a similar civic send-off to the one that the Kitchener Recruits had received. A letter to the local newspaper was headed 'out of sight, out of mind':

> The members of the 11th (Ilkley) Battery of the Brigade have learned with pleasure from your columns of the generous treatment accorded to the local Kitchener's Army recruits in the way of small gifts of tobacco etc. Whilst acknowledging the magnanimity of the donors, they feel generally that their own claims to such small marks of favour have been somewhat neglected. The bulk of their men are those who have joined in sufficient time prior to the outbreak of this war to make themselves something more than recruits.
>
> They joined in a time of peace and soberness, not on a wave of fierce enthusiasm, aroused by earnest but overwrought orators, and still their months and years of self-sacrifice of evenings, Saturday afternoons and annual holidays has lacked even the slightest mark of acknowledgment on the part of the town's people.

The following week, some of the Howitzer Brigade had been at home on leave, and the *Ilkley Gazette* addressed the issue of disgruntlement among them:

> They were very sore about so much being made of the Kitchener Recruits, not only on account of the gifts of pipes and tobacco, but in consequence of the praise bestowed upon these men in describing them as 'The Pride of Ilkley.'
>
> 'Pride of Ilkley' said a corporal, pulling a copy of the Gazette out of his pocket containing a photo of men on the march, 'Did you ever see a soldier with his hands in his pockets, for there's one here, and the very first man of the lot'. We looked, and so it was...'
>
> 'We're noan particular for yer pipes an' 'bacca' said another, 'we're aht for summat better. We mean to cum back wi' two medals on wor breasts'.

Venturing to remark that we hoped they would never be called upon to leave England, we were told that nearly every man had volunteered for the front, and that if Lord Kitchener did not let them go before the recruits, 'they'd chuck t' job' as soon as the war was over and have no more to do with either the Territorials or any other branch of the King's service.

However, when the men returned to Doncaster on Sunday evening, the Ilkley station platform was crowded with people cheering and the brass band was playing:

One man who had spoken most bitterly about the treatment of the Territorials in the afternoon was overjoyed with the reception and exclaimed, 'This is splendid! We are all satisfied! Good Luck! We are going to get those medals whatever they cost!'... The train passed out of the station, and the last we saw of him was his hand out of the carriage window waving a final farewell.

CHAPTER 3

MILITARY VISITORS

In the latter part of the nineteenth century, Rombalds Moor came close to becoming the base for the large musketry camp, which eventually settled at Strensall in 1888. However, military visitors continued to be attracted to Ilkley in the early years of the twentieth century for similar reasons – good railway communications, proximity to good sites for manoeuvres and shooting practice, an ample and pure water supply and a thriving economy to enable the availability of materials, labour and utilities. In turn, many businesses in the town benefited, particularly within the catering and hospitality trade. Ilkley Council played a vital role in enabling the efficient organisation of the camps.

In the early years of the century, the many part-time military units already organised around the country sought good sites for their annual training camps. On 26 May 1901, the 1st Company of the Lancashire Royal Engineers visited Ilkley. In 1902, the 3rd Company of the Lancashire Engineers first came to the town, and the 2nd and 3rd Companies became regular visitors. The early camps occupied the field attached to the Bridge Pleasure Ground on the south side of the river in Bridge Lane.

In 1906, the Lancashire Engineers moved to Denton on the field adjoining Ben Rhydding Bridge. In June of that year, the formal opening of the New Bridge was delayed to coincide with their arrival. The 2nd and 3rd Lancashire Engineers traditionally held their camps at Whitsuntide and average numbers were usually between 450 and 500 men, while other camps came in August.

Further military visitors to the town included the University Officer Training Corps from Aberystwyth and Durham who came to Ilkley for their annual camp in 1912. This provoked some debate as to whether military training should be part of a university education. At Durham, articles discussing the subject appeared in the University Journal and debates were held in the union society.

Nevertheless, in the following year, the largest camp in the town came in July 1913 when an estimated 2,300 officers and men of the Senior Division of the Officers Training Corps arrived for a fortnight's training. Contingents from thirteen different universities and colleges constituted the Brigade. Officer Cadets from Birmingham, Bristol and Durham arrived by train and occupied both the 'West Holmes' field rugby ground and the 'East Holmes' field. The Leeds, Manchester, Sheffield and Nottingham

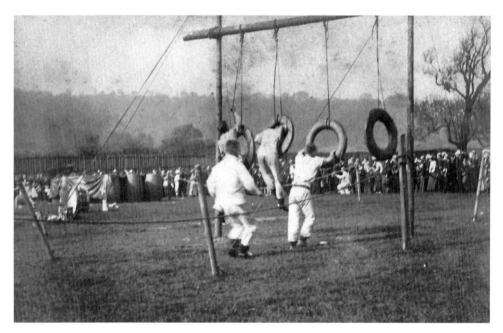

Camp sports at the 3rd Lancashire Royal Engineer volunteer's camp, *c.* 1902 – the days before car tyres were readily available.

Crowds of onlookers watch the 3rd Lancashire Royal Engineers' train departing from Ilkley towards Skipton, over the Brook Street Bridge, *c.* 1902. James Mason, butcher, is on the right.

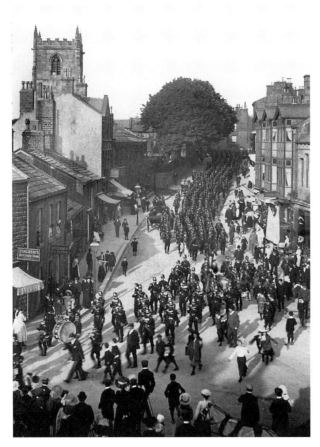

Left: The 3rd Lancashire Royal
Engineers marching down
Church Street, *c.* 1903. By 1905,
the Old Star Inn, seen in the
distance, was being rebuilt as
part of the improvements to
clear the congestion of inns,
which formed a dogleg bend
from Church Street into Leeds
Road, and to make way for the
New Bridge.

Below: The 1st Lancashire
Royal Engineers camp on the
West Holmes field, Denton
Road, looking north to
Middleton in August 1903. The
company of volunteers had been
formed in 1859 and was raised
in Liverpool. From 1908, they
became a Territorial Army unit.

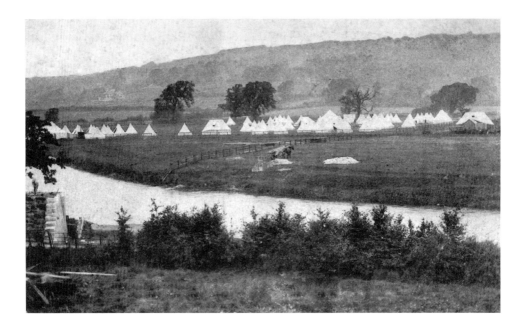

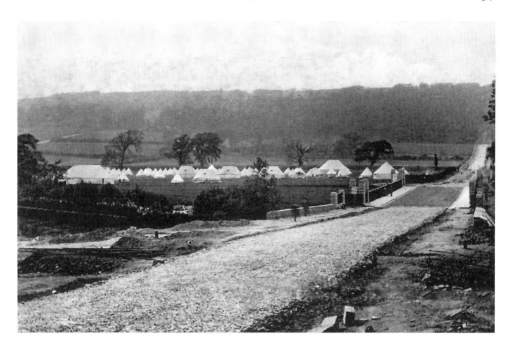

Above: The 3rd Lancashire Royal
Engineers camp at Whitsuntide,
1905. On the right, the 'New Bridge'
is under construction as part of the
scheme to develop the Middleton
side of the river. The scheme was
fortunately never carried out as
originally planned, as it would have
destroyed a much greater area of
woodland. The bridge was officially
opened a year later in June 1906 by
cllr J. A. Middlebrook – manager
and secretary of the Ilkley Brewery
& Aerated Water Co. The actual
opening of the bridge was delayed
to coincide with the arrival of the
engineers. They were the first body
of men officially to pass over the
bridge.

Right: The 1st Lancashire Royal
Engineers parade from the railway
station down Brook Street to
their camp on the West Holmes
field, *c.* 1905. The band are in
the foreground, followed by the
infantry soldiers.

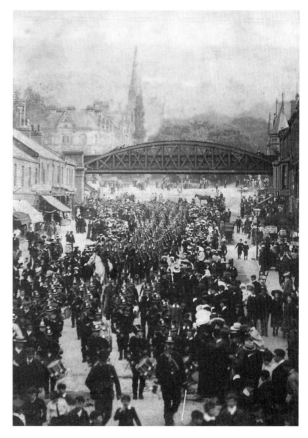

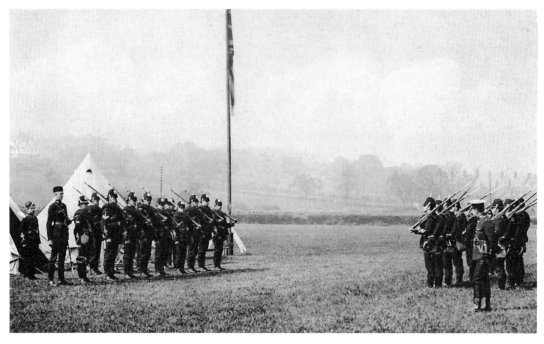

The 3rd Lancashire Royal Engineers inspection at their camp in June 1906.

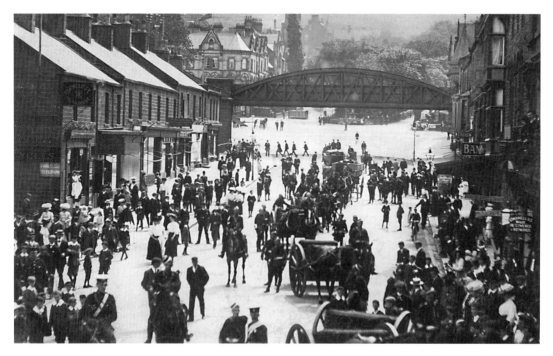

The mounted section of the 2nd Lancashire Royal Engineers arriving in Brook Street on 5 August 1906. The horses and equipment were unloaded at Ilkley while most of the men arrived later, disembarking at Ben Rhydding, closer to camp.

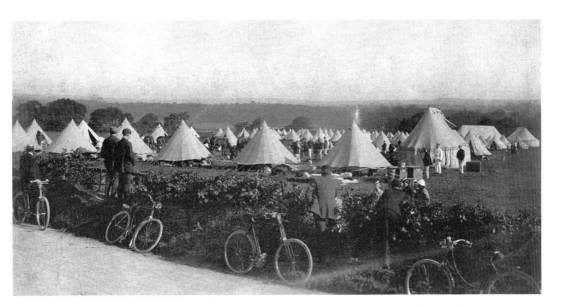

The 2nd Lancashire Engineers camp. In 1906, the Lancashire Engineers had moved to Denton on a field owned by the timber merchant, Arthur Green, providing a larger area for fieldworks.

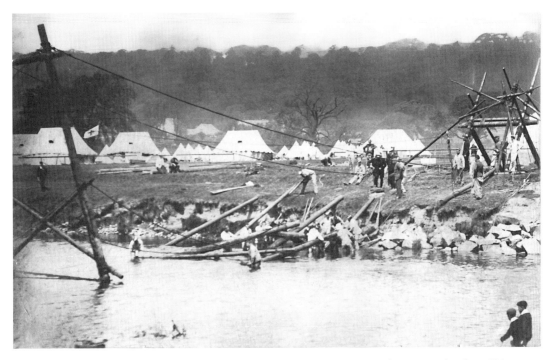

Bridge building in progress at the 2nd Lancashire Engineers camp. The River Wharfe at Ilkley and Ben Rhydding provided a good stretch of river for bridging exercises. The *Ilkley Gazette* of 7 August 1906 states that the finished trestle bridge consisted of 'a structure of 120ft long, 9ft wide and erected from banks 12ft high. The roadway was suspended on two and four legged trestles.'

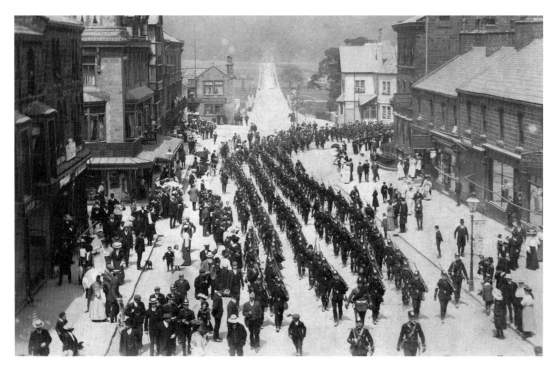

Lancashire Engineers parade up Brook Street, *c.* 1907.

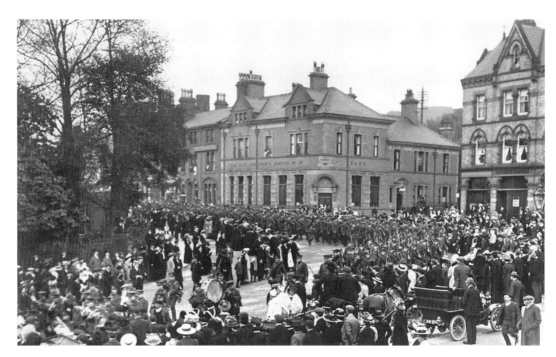

Troops arriving in Ilkley turning the corner at the top of Brook Street and Station Road, led by the band. Large crowds assembled to welcome the Engineers.

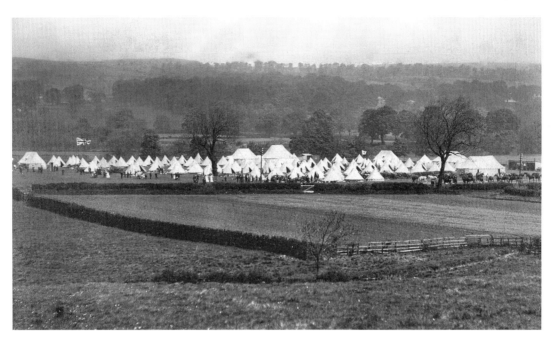

This photograph is from a postcard postmarked 6 July 1909, with the message: 'Dear Mother ... This is a postcard of the camp at Ben Rhydding where the soldiers are. They are giving a concert in the park this afternoon. Think I am going. It is a splendid band and the town is very lively.'

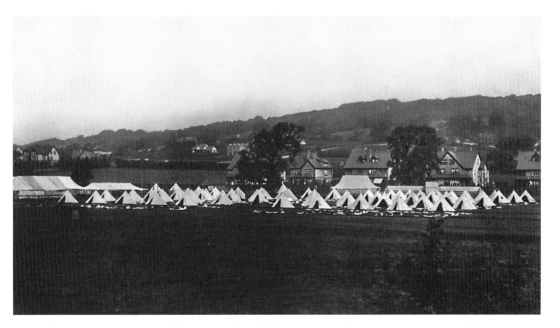

Officer Training Camp on the West Holmes field in 1912. In that year, Septimus Wray, the owner of the Pleasure Gardens, purchased the West and East Holmes fields; previously he had rented them. The houses behind the fields are on Denton Road and were built by local builders Dean and Mennell in the first decade of the century.

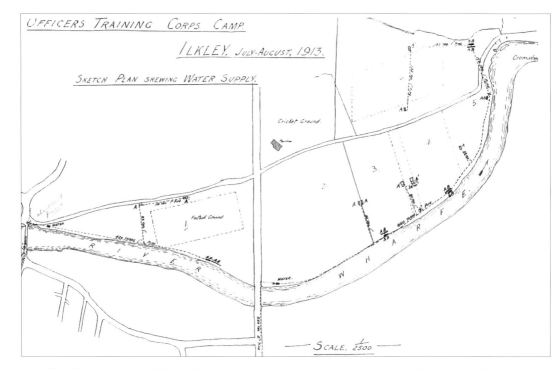

Sketch plan of the Officer's Training Corps camp along the River Wharfe in July and August 1913, showing the water supply. The map shows the camp fields marked Nos. 1–6. Fields 1, 3, 4 and 6 are battalion camps. Field 2 is the staff camp and 5 the hospital camp. The small rectangles show the sites for cooking, shelters, showers and 'ablution benches'.

men formed No. 2 battalion. No. 3 battalion included the Officer Training Corps Cadets of St Andrew's University, Edinburgh University and Glasgow University. London, Reading and Aberystwyth men formed the No. 4 battalion. The Glasgow men arrived at the railway station, accompanied by a kilted pipe band. A pipe and drum band played 'Scotland the Brave' as the Edinburgh and St Andrew's contingent marched into camp. One participant recorded his experiences in the Dundee University college magazine:

> Ilkley is the sort of place that rises up and hits you in the face as soon as you come near it, a bustling seaside resort without the seaside. On our arrival we marched through the streets, our big drummer did his best to awaken any vestiges of martial spirit that might be hidden behind the inane stare of the onlooking crowd.

A correspondent to the Arbroath High School magazine said this of Ilkley:

> The old Roman town experienced military excitement, which the district has not known since Agricola's legions: the strange spectacle of bare necked warriors led by swaggering pipers with full blown cheeks and bulging eyes. Through the course of

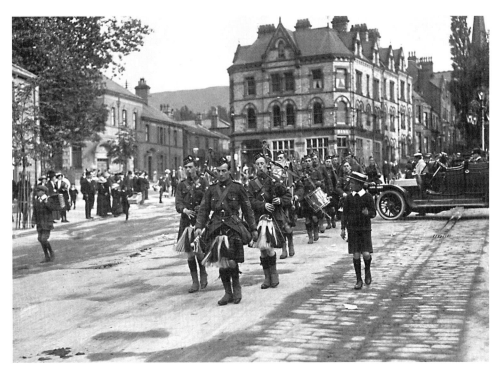

The Officer Training Camp in 1913 was attended by men from thirteen universities, including Edinburgh, Glasgow and St Andrews. As their units marched from the station to the Holmes fields on Saturday 19 July, accompanied by their kilted pipers and drummers, 'they were an object of great interest', reported the *Ilkley Gazette*.

years many hundreds will look back very happily on a sunny English summer in a little corner of the Garden of Eden by the banks of the hazel-fringed Wharfe.

The campsite was made up of approximately 430 bell tents along with cookhouses, stores and other wooden huts. There were thirty-eight government marquees used for officers and men's messes, canteens and lounges. A typical day in camp for the cadets started with 'reveille' at 5.30 a.m. After breakfast, the battalions were engaged in infantry drill and tactical exercises on the moors on each side of the valley, as well as trench digging. During the evenings, there were various lectures including one by Maj. J. E. Gough, who had received the Victoria Cross in the South African War. Sporting events between the battalions were popular, especially cricket. Lights out was at 10.15 p.m.

Once the camp duties had been done after tea, the public were allowed to inspect the camp and the cadets who could be spared were allowed to visit the town. High spirits were reported by the *Ilkley Gazette*, including a mischievous incident at White Wells:

During the night, the appearance of the Old White Wells on the moor underwent a considerable change. The exterior of the building was streaked with pink and

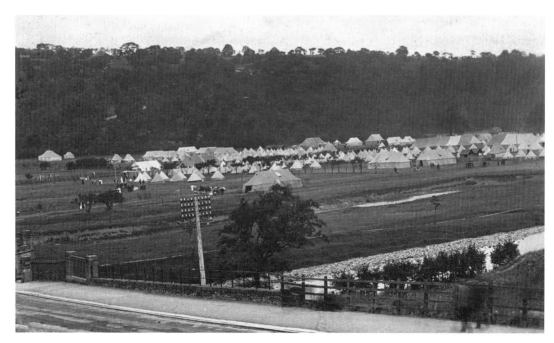

Officer Training Camp in the East Holmes field, 1913 – a view from the New Bridge looking north-east. Photographs were taken and quickly reproduced as postcards by local stationers and printers. This one was sent to Sussex on 22 July 1913 with the message: 'We are having a most ripping time ... we have the Scotch Contingents near our lines and the bagpipes are going all day long. Just wish you could all come to see this lovely spot.'

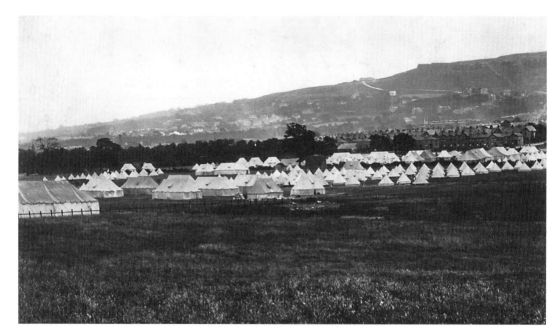

Officer Training Camp, facing south-east towards Ilkley Moor and the Cow and Calf, 1913.

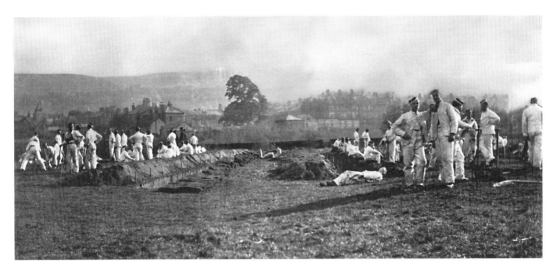

With the accommodation of such a large unit of men, housekeeping was a priority. Great attention was paid to sewage disposal and water supply. Here men appear to be digging the latrine pits in an area to the south-east of the West Holmes field.

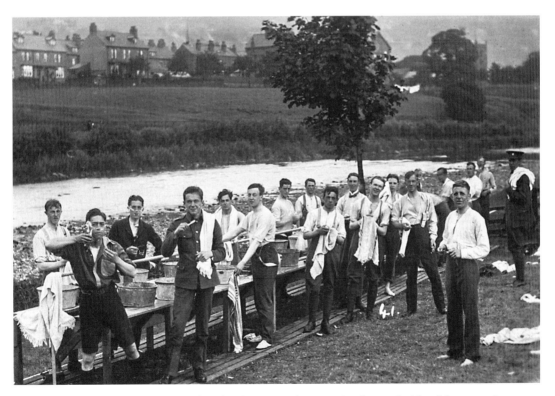

Demonstration of the 'ablution bench' adjacent to the river. On the south side of the camp there was washing, shaving, toothbrushing and a motley assortment of towels. A contract from the War Office for Ilkley's water supply estimated that around 1,800 gallons of water per day would be required for the camp.

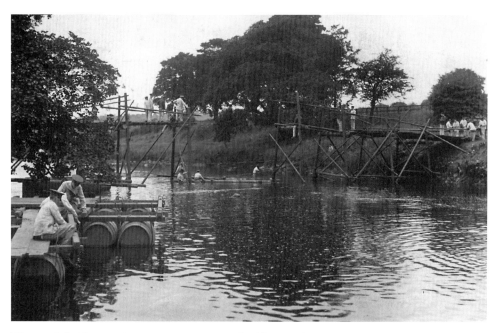

The trestle bridge training exercise near Ben Rhydding Bridge in August 1913.

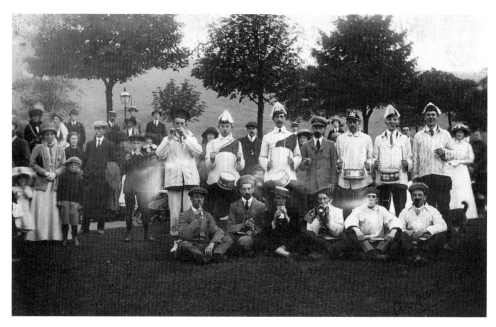

Officer Training Camp mock band, taken near the West View bandstand at the top of Wells Road, July 1913. The *Ilkley Gazette* reported that, 'fun and frolic found favour with the more boisterous young fellows and there were some very laughable incidents. During one evening of the Municipal Orchestra in West View Park, a cordon of cadets danced around the bandstand to rag-time and other music and the same hilarious incidents were associated with the lamp posts of Brook Street.'

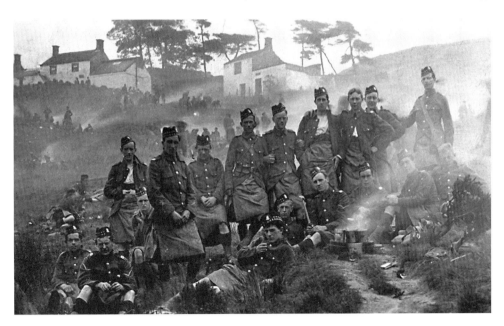

Scottish Officer Cadets cooking dinner at White Wells in 1913. During the camp, the *Ilkley Gazette* reported that as a prank White Wells was painted in bright colours by cadets from the Officer Training Camp, but the culprits were never discovered.

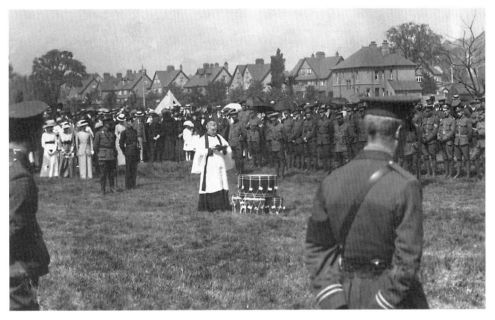

On Sunday 13 July 1913, there was a drumhead service in the West Holmes field following a church parade. The Scottish battalions did not attend as their chaplain was not in the camp. Members attended services at their respective places of worship in the town. On the following Sunday morning, there were two drumhead services – one taken by the Revd Ellershaw, Church of England, and the Revd Dr Cooper, Church of Scotland. They were also attended by the public.

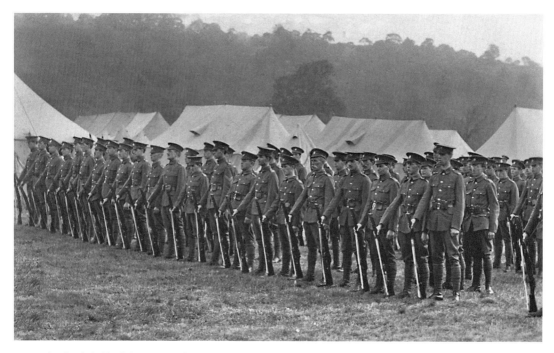

The final drill of the camp of 1913 was on Friday 1 August of that same year. Gen. Sir Charles Douglas from the 92nd Highlanders attended the camp for the annual inspection, which included a full ceremonial parade in a field off Beckfoot Farm and tactical exercises on the moor.

green distemper; though the intention was to use a wash which would give the walls a tricoloured appearance, but the red and blue colours necessary were not forthcoming.

More than half a century later, in July 1969, this prank was alluded to in a letter to the newspaper, although there still appeared to be some anomalies in the tale regarding the colours used:

Having devoted much time in the west of England, I note most of these visitors to this district refer to Ilkley as that place with a 'white house' on the hill. As a matter of fact, one very prominent resident living in the Cheddar Gorge area was responsible for the 'White House' being painted blue during the First World War.

Cryptically, the letter was signed off under the name 'One who knows'.

Following the outbreak of war, military units continued to visit the town for training; however, the mood of high spirits before the war had turned to the serious business of training civilians to become hardened soldiers who would be prepared to fight to the end for king and country on foreign soil.

At the end of March 1915, the first of two field companies of Royal Engineers recruited from Leeds arrived in Ilkley for their training camp. The two companies, the 210th and

211th Field Artillery, were formed by 600 men. The *Ilkley Gazette* reported that a large crowd gathered at the top of Brook Street to meet the Royal Engineers who arrived by train. The crowd included wounded soldiers from the auxiliary military hospital on The Grove. After marching to their HQ in St Margaret's Hall in Regent Road, the men were sent to their billets. The base at St Margaret's Hall was run by a committee from St Margaret's church and provided games, newspapers, writing materials and refreshments.

At the end of May 1915, following further recruiting in Leeds, the other units of the Leeds Royal Engineers, the 223rd Field Company and 31st Divisional Signal Company arrived in Ilkley. This Field Company consisted of 300 men and the Signal Company, 200 men. Together, the three field companies and a signal company formed a division of 1,100 engineers – the 31st Division.

Horses were in short supply for the engineers' training, many having been previously purchased from local farmers by the government for war purposes. The problem was solved by obtaining mules. Forty of these animals were acquired from the Argentine Republic for the use of the Royal Engineers in Ilkley. On the arrival of the mules, the *Ilkley Gazette* reported:

> They looked a fine selection, though some are addicted to a particularly unpleasant habit, and that 'wanting to shake hands when you aren't looking', to quote an expression one of the men used after experiencing something in the nature of a bit of kicking, both fore and aft, on the part of one of them.

During their posting in Ilkley, the training of the engineers included road building at Middleton. They left Ilkley early on 21 June 1915, marching over Askwith Moor to Ripon. This was a full day on the march, with ten minutes rest each hour and two meal stops en route.

Between February and May 1915, Ilkley was the base for another company from Leeds – the 17th West Yorkshire Regiment. This was a 'Bantam' regiment consisting of men who were below the previous regulation height of 5ft 3in when the war started. Early in the war, as it became clearer that more men would be required to volunteer, the height regulations were relaxed and Bantam regiments were created in towns and cities across the country. Many of these men brought key skills such as experience in the coal mining industry, useful at the front to dig tunnels filled with high explosives under the enemy positions.

By 1917, however, high casualty rates among the Bantam regiments and an appreciation of the heavy physical requirements of an infantry soldier in trench warfare meant that they were absorbed into the regular army units to serve alongside men of a more average height. In the winter of 1917, the Leeds Bantams were absorbed into the senior Leeds Service Battalion – the 15th West Yorkshires.

Recruitment for the Leeds Bantams had started late in 1914. The Leeds Bantams used the East Holmes for parade and drill. They were billeted in some of the empty or less frequented hydros, as well as private houses. One of their billets was the Troutbeck, which had been closed for a number of years. The men did not appreciate the damp atmosphere, as the *Leeds and District Weekly Citizen* reported in February 1915:

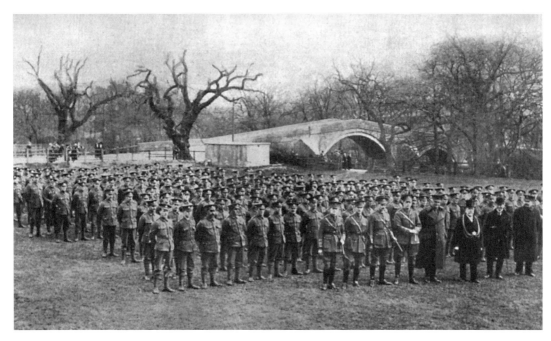

Leeds Royal Engineers, 210th Company, inspection by the Lord Mayor of Leeds, Mr James E. Bedford near Ilkley Old Bridge on 2 April 1915. Maj. Hopper, a Leeds engineer who had military experience in the South African War, was commander of the Field Companies from Leeds. The first of the new companies left Leeds to start training in Ilkley on 30 March 1915. They were later followed by the other units.

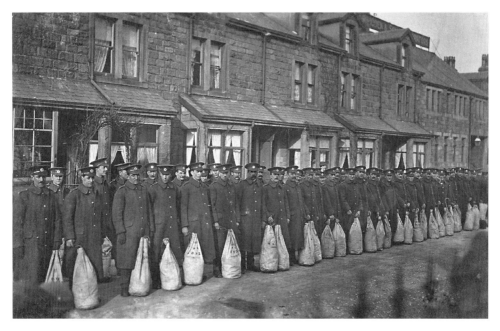

Leeds Royal Engineers, 210th Field Company, Regent Road, March 1915.

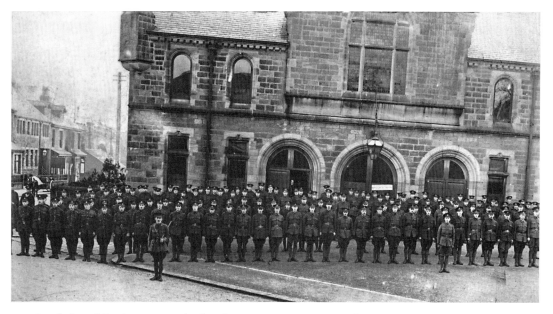

Leeds Royal Engineers outside their base in St Margaret's Hall on Regent Road in 1915. The base was run by a committee from St Margaret's church and provided games, newspapers, writing materials and refreshments.

There is an old hydro at Ilkley that has a misspent past. It has given no useful service for some years, and now it is required by the Leeds Bantams. A plentiful supply of wet weather and a lack of fires for years have left the building very damp, with the wallpaper falling off, and the Bantams quartered there don't like it. In fact, it has made some of them ill.

The relative proximity of their home city of Leeds proved to be too great a temptation for some of the men who chanced visits home and were unlucky to get caught. 'Before the beaks' was the headline of the following passage from the *Ilkley Gazette:*

At the Leeds Police Court on Monday, a number of soldiers were brought up on charges of leaving the Headquarters of their Regiments without permission, or for having extended their leave. These included twelve Leeds Bantams and also one of the Royal Engineers billeted at Ilkley. They were all remanded to await escorts.

Following their training in Ilkley, the Bantams left for camp at Masham. It was not until July 1916 that the battalion crossed the channel. Their first experience of a major battle was on the Somme.

In August 1916, Ilkley hosted another camp based on the cricket ground on Denton Road for a week's military training. This was the Imperial Cadet Yeomanry, a territorial unit of the Officer Training Corps affiliated to the Yorkshire Hussars. New recruits to the unit had to be 'not over military age and not under 5ft 2in in height'.

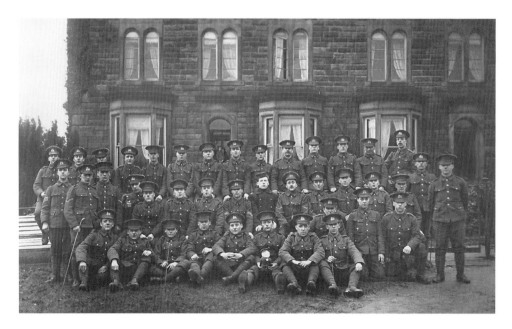

A group of Leeds Bantams from the 17th West Yorkshire Regiment (Prince of Wales' Own) billeted in Ilkley in 1915 outside Hill Side House. The Bantams were battalions of men who were under regulation height of 5ft 3inches but were otherwise fit for service. The 17th West Yorkshire Regiment had been raised in December 1914.

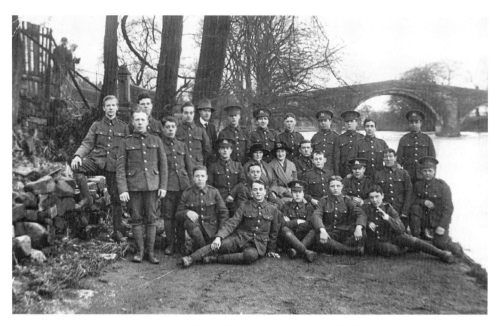

A group of Leeds Bantams with the Old Bridge in the background, February 1915. The battalion trained at Leeds, Ilkley and Skipton. In June 1915, a Bantams officer, Ernest Roscoe, was killed in a motor accident near Chelker Reservoir, while returning to their camp in Skipton after visiting Ilkley to see a film of the battalion when it was in training at Ilkley.

The attendees at Ilkley were approximately fourteen years old. At this time, the unit numbered around 200. The Ilkley camp was formed from detachments from the Leeds and Bradford squadrons. Since the beginning of the war, many ex-cadets of the unit had transferred to various branches of the forces. In addition to this, the unit trained approximately 250 men under Lord Derby's scheme for cavalry units.

In late July and early August 1917, around 150 young men from Archbishop Holgate's School, York; Woodhouse Grove School, Apperley Bridge; Wheelwright Grammar School, Dewsbury; and the Leeds Modern School attended a Territorial cadet training camp held on the cricket field in Ben Rhydding. The *Ilkley Gazette* reported:

> The site is an ideal one for the purpose, being away from the town and other distractions, and with all they require in the way of reading, writing and entertainment provided in the YMCA tent, there is not that desire to wander far from the camp as without these advantages there would most assuredly have been.

On 17 August 1918, 850 officers and cadets of the 7th Manchester Church Lads Brigade King's Royal Rifles camped on the West Holmes rugby field for a week's training. The cadets were aged between thirteen and eighteen and had each contributed 25 shillings towards the cost of their camp. 'There is a canteen and all other equipment and arrangements incidental to an ordinary military camp, although nothing stronger than "pop" is sold at the canteen.'

CHAPTER 4

REFUGEES FROM BELGIUM

During the rapid German advance at the beginning of the war, men, women and children from Belgium fled to France, Holland and Britain. In September 1914, the British Government offered hospitality to the refugees and arrangements were put in place for their transport and accommodation. The War Refugees Committee, a central voluntary body, directed several thousand local committees who were responsible for arranging for the refugees to be met at ports and stations and for providing for their needs including shelter, food, clothing and employment. The Belgians were posted to many parts of the country. Destinations in West Yorkshire included Leeds, Bradford, Keighley, Otley, Bingley, Huddersfield, Wakefield and Ilkley.

The success of the relief effort in the early stages of the war reflects the strength of the philanthropic ideal in the early part of the twentieth century and the key part that women played in taking on an increasingly wider range of roles. In Ilkley, the Ladies Belgian Hospitality Committee was formed at a meeting at the town hall on 9 September 1914, chaired by Mrs Helen Rabagliati.

A telegram to the Central Committee in London was dispatched the following day offering hospitality to refugees, and an appeal was issued for funds and other offers of help. A finance committee was formed and, by the beginning of October, they had over £600 in the bank in addition to numerous promises of subscriptions. Meanwhile, offers of private hospitality, the loan of empty houses and furniture, as well as gifts of food and other necessities, had been received and a range of fundraising activities followed. Initially, the majority of the cost of maintenance of all the refugees in Ilkley was met by local subscriptions. However, in July 1915, costs began to be borne equally between the government and the local committee.

The first party of forty-six Belgian refugees arrived in Ilkley from London on 30 September 1914. They were met by welcome committees at the railway station. Their arrival aroused deep interest and crowds of people gathered to greet them. The *Ilkley Gazette* reported on their arrival:

> They were immediately conveyed to the PSA Hall in open carriages, and a conveyance followed containing the whole of their worldly possessions – a number of bundles of clothing and bedding. They were wearing all manner and style of garments, most

provided since their arrival in England, though some still possessed part of their native dress, and several were wearing sabots, which clattered on the pavement and seemed to English minds, very clumsy and inelegant.

Thousands of people gathered to witness their arrival and not only crowded the Railway Station yard and vicinity, but also the top of Brook Street, Railway Road and the PSA Hall approaches. There was no enthusiastic display of welcome, but it was a very hearty welcome all the same; full hearts and tear dimmed eyes speaking volumes of sympathy and kindly feeling on every hand.

However, several weeks later, the natural curiosity of local people and their well meant intentions towards the Belgians prompted Mrs Rabagliati and the chair of the Refugee Committee, Mr Dobson, to write to the *Ilkley Gazette*:

The desire to show affectionate interest in the little stranger children is natural enough, but there is no real kindness in putting sweets into their mouths or pennies into their hands whenever they are seen. The constant eating of sweets makes the children ill, while the too frequent bestowal of pennies comes dangerously near to children forming the habit of begging. Similarly, the offer of drinks to the men is

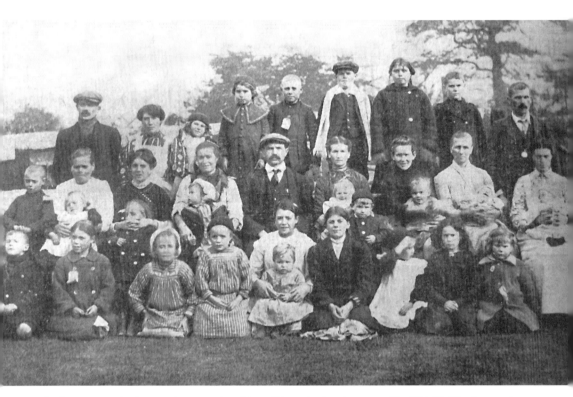

The first group of Belgian refugees at the PSA Hall in early October 1914. The PSA Hall had opened in 1902 and was located in a wooden structure on North Parade. In 1935, it was taken over by the Salvation Army, and served the local community until the land was developed in the 1950s.

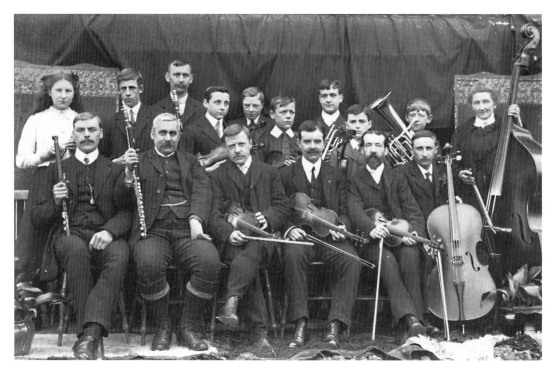

The PSA Band in 1911. The PSA or 'Pleasant Sunday Afternoon' was an organisation established in the late nineteenth century with links to Nonconformist churches. It had the aim of giving men alternative social activities away from drinking in public houses.

meant as an expression of good-will, but is no true kindness – quite the reverse; and already this has had its inevitable bad effects. The very light wine or beer which the Belgian peasant drinks at home are totally different from the strong drinks offered him here, and he is not prepared for the difference.

The intention of the letter was to dissuade curiosity and misguided kindness towards the Belgians in the town. However, it reflects the cultural influences of the time. The consumption of alcohol, particularly beer, was increasingly seen as a threat to the war effort. Chancellor David Lloyd George famously said, 'We are fighting Germany, Austria and drink ... and as far as I can see, the greatest of these deadly foes is drink.'

In 1915, the government introduced restrictions to the opening hours of public houses at home in an attempt to curb excessive drinking. Yet the rum ration had been introduced in the winter of 1915 for soldiers in Flanders to combat the damp of the trenches, and to provide a glow of comfort for men who found themselves caught up in harrowing events. The letter by Mrs Rabagliati to the *Ilkley Gazette* went on to suggest that a more practical way to help the refugees would be to donate small sums of money to a fund, which would accumulate until it was time for the Belgians to return home when it would be distributed amongst them. A collection box was fitted to the former council chambers on The Grove for this purpose.

Meanwhile, the refugees who were initially billeted in the PSA Hall on North Parade had been found more permanent lodgings in various houses around the town, including the home of Mrs Rabagliati at Whinbrae on Wheatley Lane. A group of the children were provided for at the orphanage. During the winter months, some twenty of the women and children stayed at the Children's Holiday Home at Highfield near the Cow and Calf.

A refugee priest, the Revd Father Faes, was appointed by the Revd Father Alfredo Galli from Sacred Heart church. At a time when priests in Belgium were in grave danger, Father Faes had managed to escape from Malines disguised as a peasant. Four refugee nuns were sent to Ilkley for a time until they were recalled for service in Belgium. Two of the nuns worked at the holiday home, and the other two in a small schoolroom for the refugees at Poplar Lodge in Tivoli Place. Once the children were able to speak some English, they were transferred to the elementary day schools, the grammar school and private schools.

Additional refugees arrived from time to time and, in July 1915, at the request of the Central Committee, between forty and fifty further Belgians of the professional class

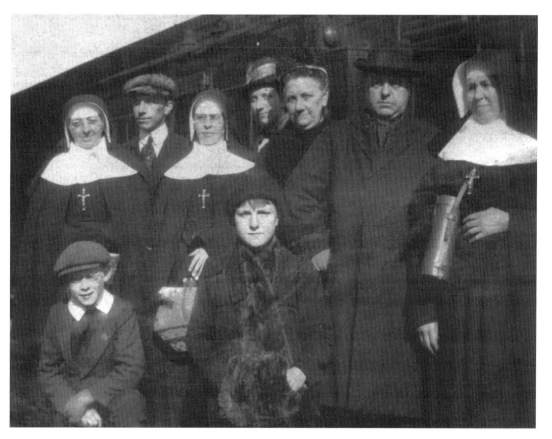

A group of Belgian refugees at Ilkley station. Several refugee nuns were sent to Ilkley for a time until they were recalled for service in Belgium.

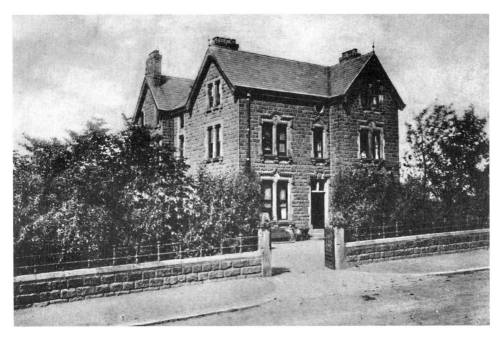

Marlborough House Hydro was home to Belgian refugees during the war. It was a smaller hydopathic establishment opened in 1878 on Clifton Road. It was demolished in 1969 and replaced by town houses.

A group of Belgians who came later than the initial group in the PSA Hall and arrived with portmanteaus rather than bundles. They were accommodated at Wortley House in Tivoli Place. They are photographed here in Belle Vue Park with Tivoli Place in the background.

arrived in Ilkley. Marlborough House Hydro was rented, furnished to house this group, and a grant from the Central Committee was given towards expenses. Many of the residents were children who attended local schools and the men found employment, some at the National Shell Factory in Leeds, others in Bradford. In January 1916, the average number of refugees from Belgium over the previous twelve-month period was 105, excluding those at Marlborough House Hydro.

A clubroom was opened in Wells Road with newspapers, games and a small library of books in French and Flemish. Here the women would sew and knit garments to send out to their army in Belgium. The report of the Ilkley Belgian Hospitality Committee in February 1916 stated that 'it was not thought desirable that the married women with children should seek employment'; however, regular employment was found for all of the men able to work.

Initially, a quarter of the wage was retained by the worker, a quarter was paid to the committee towards maintenance and the remainder was placed in a repatriation fund to be given to the wage-earner on his return to Belgium. However, this was discontinued by the Central Authority in October 1915, when three quarters of the wage went to the committee.

After the war, Mrs Rabagliati and Miss Nussey of the Ladies Committee were awarded the *Medaille de la Reine Elizabeth* for their work with the refugees. On 5 February 1919, most of the refugees left for their own country. A farewell party for around ninety refugees had been held on the previous evening in the King's Hall, which had been decorated with flags of the allies, streamers and various national emblems.

The Belgians had presented a marble tablet to the town in the council chamber of the town hall in December 1918 with an inscription in gilt letters: 'Great War, 1914–1918. In grateful acknowledgement of the kindness of the Belgian Committee, and the people of Ilkley, Ben Rhydding and Addingham. From the Belgian Refugees.'

Forty-eight of the Belgians residing in the Ilkley district left for Antwerp via Leeds and Hull. These were made up of around twenty Belgian families, including some small children who had been born in England. Two of this group were thought to be the two oldest refugees in England – M. Struyf and his wife, aged eighty-eight and ninety-two. Before the war, M. Struyf was a grain merchant in Louvain. He said to the reporter of the *Ilkley Gazette* before their departure: 'England is a very nice country and I should have liked to stay but I am a Belgian.' About forty refugees remained in Ilkley.

Many Ilkley people gathered in the railway station to witness their departure, and the Ilkley Hospitality Committee provided coffee and refreshments for the journey.

It was not a pleasant sight to witness their departure, with the knowledge of the comfortable circumstances they are leaving, and the immediate prospect of anything very pleasant awaiting them in their own country, and a feeling of sadness seemed to be general, for the train was allowed to pass silently outwards, with no demonstration of any kind beyond the waving of hands and handkerchiefs.

In February 1919, the *Ilkley Gazette* reported on the prospects awaiting them upon their return:

Belgian Refugees all over the country are returning to their homes, or what remains of such; most of those resident in this district leaving Ilkley on Wednesday morning.

There were people who thought that experiencing all the kindness, sympathy, and consideration the refugees have done during their sojourn in this hospitable island of ours, they would be very loth indeed to return to their own devastated and ruined country, but evidently such did not realise the strength of the home instinct and love of country, with no experiences of the sorrows and sufferings of outcasts and exiles separated from all they love and honour, and the 'homesickness' banishment engendered.

Ilkley has looked well after the Belgians who have found refuge in our midst, and we know they are very grateful for all the kindness we have shown them. Their hearts are naturally in their fatherland, and now that they are leaving the shores that have been to them a blessed sanctuary of peace and safety, we trust that the memory of all they have suffered before they came to us, revived by the scenes of utter desolation and sorrow they are bound to witness, will not long have a depressing influence on any of them, but that they will set their hands and steel their hearts to the rebuilding of a better and happier Belgium than they have hitherto known.

ILKLEY,
February 4, 1919.

Farewell Party to Belgians and their Ilkley Friends.

6 o'clock – TEA.
7 o'clock – MUSIC.
8 o'clock – SPEECHES by the Belgian Consul (Mr. J. D. Law), and others.

La Brabançonne.

God Save the King.

NEITHER Belgians nor British will forget these four years of friendship, of sympathy in common anxiety and sorrow, of united thankfulness. The Entente has become a real understanding of mutual respect and affection, to remain unbroken.

Au Revoir.

A farewell party for the Belgian refugees was held at the King's Hall on 4 February 1919. Mr J. D. Law, the Belgian consul at Bradford, spoke of how much they appreciated the kindness the Belgians had received in Ilkley and had come to love those associated with this hospitality work.

CHAPTER 5

CARE OF THE SICK AND WOUNDED

With the outbreak of war, the Red Cross established temporary hospitals to ease pressure on the large military hospitals. These were set up in a wide range of buildings across the country, from town halls and schools to private houses. These auxiliary hospitals were attached to central military hospitals. In Yorkshire, the central hospitals were in Leeds and Sheffield.

Some of the first auxiliary hospitals to be established were in the larger, most suitable premises such as the Ilkley Convalescent Home on The Grove. Predominantly funded by subscriptions before the war, it had provided rest and recuperation for working people, many of them from the manufacturing areas of the West Riding. At the start of the war, after being re-equipped and organised for war purposes, it was attached to No. 2 Northern General Hospital at Beckett's Park in Leeds as 'Ilkley Auxiliary Military Hospital No. 1'. Auxiliary hospitals affiliated to the Beckett's Park Hospital in Leeds were established in many towns and cities across West Riding, including Bradford, Keighley, Guiseley, Harrogate, Huddersfield, Dewsbury and Wakefield.

On 19 August 1914, fifty beds for invalid soldiers and sailors were requested by the Lord Lieutenant of Yorkshire. The hospital already had commitments to their subscribers and patients and, on 21 August 1914, the committee resolved to send a letter undertaking to provide at least twenty beds up to the end of October. After that date, the whole of the accommodation of 100 beds was promised.

However, these local negotiations were overtaken by world events. Before the hospital came completely under the control of the military authorities, a request was made for it to receive wounded soldiers from Belgium. These men were among the many who were rushed to this country following the fall of Antwerp during the rapid advance of the German Army. The relatively small Belgian Army, with some British Army support, had encountered deep opposition. After eleven days of heavy fighting, the city of Antwerp was taken by the German Army on 2 October 1914, and the Belgians were forced to retreat westwards. A stream of wounded soldiers arrived in this country.

In the early hours of 16 October 1914, sixty-two wounded soldiers arrived in Ilkley by train. The realities of war were brought home to Ilkley people as the *Ilkley Gazette* reported, 'We had come to realise something of the misery and suffering caused by the

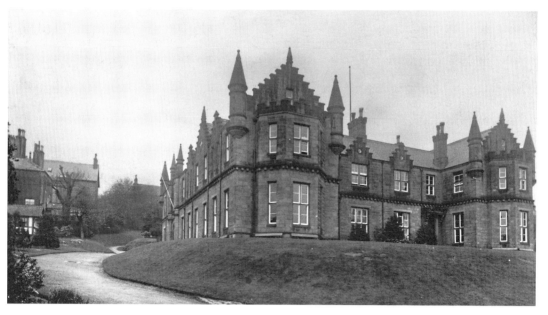

Ikley's first auxiliary hospital was the convalescent home on The Grove. This opened in 1862 as the Bath Charity Hospital to provide treatment for the poor, and was built in the Elizabethan style. Before the war, it provided rest for working people from the surrounding towns.

Pre-war interior view of The Grove Hospital and Convalescent Home showing the comfortable accommodation offered. The Auxiliary Military Hospital reverted to its former civilian role in early 1919.

war through the advent of several batches of Belgian refugees, but now its awfulness has been still more impressed upon us.'

The men were met at the railway station by Mr Dobson (chairman of the council), about forty volunteers from the Ilkley detachment of the St John Ambulance Association and a crowd of curious onlookers. The soldiers were conveyed to the hospital in private cars, apart from two men with leg injuries from shrapnel who had to be taken on stretchers:

> One or two men were still fully equipped for fighting, and looked almost ready to return. They ranged in appearance from mere youths to bearded men in middle life, and looked a fine hardy set of warriors all round. There were relic hunters amongst the crowd, and one seemed mighty pleased in securing a button off one of the men's coats. The following morning, those men who were able to walk about the grounds attracted the interest of many people and a crowd gathered near The Grove entrance. Here, most of the wounded congregated and were the recipients of cigarettes, sweets, and also money, numbers of souvenirs being secured in return for such gifts.

These men remained in the hospital until December. In November and December 1914, a further eighty wounded Belgian soldiers, who had fought at Liege, Namur, Aerschot, or Louvain, arrived at the hospital.

Towards the end of 1914, the Ilkley Convalescent Hospital saw the arrival of British soldiers for the first time. A contingent of eleven men was sent from the Second

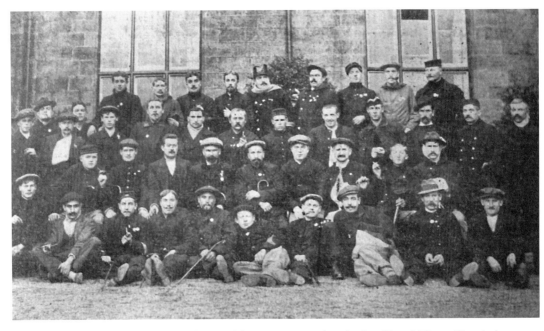

In the early stages of the war, Belgian soldiers were treated at the Auxiliary Military Hospital on The Grove.

Northern General Hospital, at Beckett's Park, Leeds, on 14 December. They were conveyed in cars. Four required stretchers, while the others could walk. They also attracted an audience:

> A small crowd of residents were gathered in the vicinity of the hospital as the cars entered the grounds, but there was no cheering or demonstration whatever. The Belgian wounded soldiers still in the hospital were very interested spectators of the proceedings. (*Ilkley Gazette*)

In May 1915, seventy men arrived who had taken part in the Battle of 'Hill 60' during the first Battle of Ypres. Over the course of the war, convalescing soldiers became a familiar sight in Ilkley. The patients at the auxiliary hospitals were generally less seriously wounded than at other more specialist hospitals. However, men were received at the hospital with a variety of wounds. Some were suffering from gas poisoning, frostbite, shell shock or accidents, as well as various illnesses. Those who recovered sufficiently were returned to duty at the front. Although the auxiliary hospitals tended to be less strict than other military hospitals and the men preferred them, patients remained under military control. Mr F. Whiteley, the secretary, had been appointed as a commandant by the military authorities.

Premises identified for auxiliary hospitals were expected to be offered on loan to the War Office and, in exchange, the hospitals were paid a rate in accordance with the number of men being treated. Initially, the Auxiliary Military Hospital No. 1 had beds

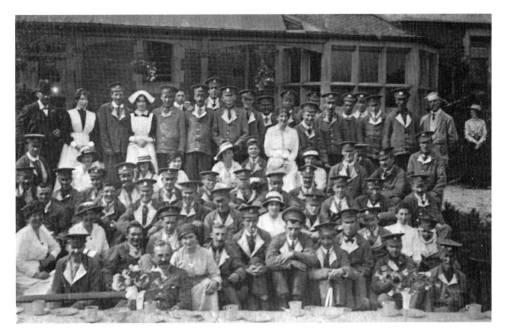

Tea party at the Auxiliary Military Hospital. Men being treated wore a blue uniform with a red tie, known as 'hospital blues'.

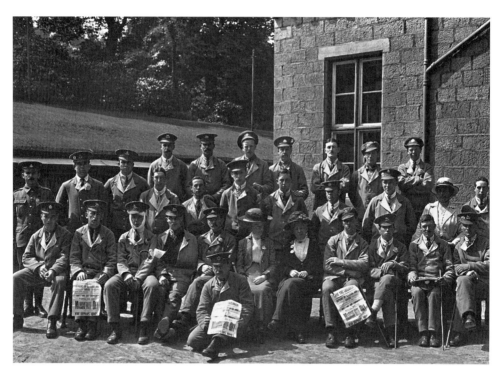

Marguerite Day at The Grove Military Hospital, 22 July 1916. The soldiers are raising money for the children's homes for orphans of soldiers and sailors who have died for their country.

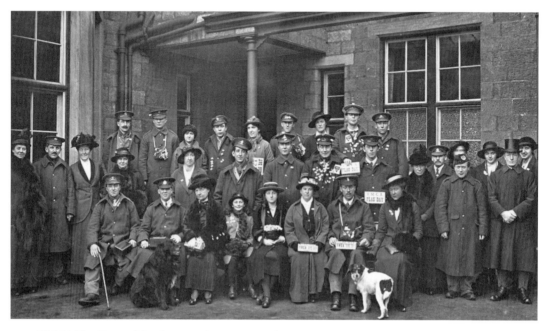

YMCA Flag Day at The Grove Military Hospital.

for 100 patients and this number was continually under treatment there throughout the war. Auxiliary hospitals had to rely on voluntary donations as the amount paid by the War Office was insufficient to fund the full range of services provided. The Grove Hospital relied heavily on fundraising events, local church collections, donations and legacies.

War loans were used to fund any necessary maintenance, such as the 'sanitary arrangements'. At the Ilkley hospital, hot water pipes to heat the bedrooms were installed at the expense of the Red Cross and, in February 1916, Mr Whiteley reported in the committee minutes that the 'short beds' had all been lengthened at the expense of the Auxiliary Military Hospital. Boys in the woodwork class at Ilkley Grammar School produced crutches for the Ilkley hospital, as well as bed tables for the Beckett's Park Hospital in Leeds.

The rising cost of food was also a major consideration. In the minutes of 21 August 1914, the treasurer recorded the cooperation of some of the local traders in this respect:

> Mr Lee reported that he had interviewed Messers Beanlands and Sons and Mr James Mason respecting their charges for groceries and meats. They both promised to do the best they possibly could and charge less than ordinary prices charged to other customers.

The staff of the hospital had been taken under the administration of the military hospital who paid their salaries. The staff included the matron, nurse, cook and maids. However, the hospital relied heavily on the local Voluntary Aid Detachment and many women in the local neighbourhood volunteered on a part-time basis as nurses and took on other duties. The men of the local St John Ambulance Corps dealt with the convoys of wounded men arriving at the railway station, assisting at the hospitals where required and as night orderlies.

The voluntary aid detachments had been formed in August 1909. Many were attached to the British Red Cross Society. As with the Territorial Force, the detachments were initially intended to be used for home defence only, but in the event many served abroad in France, Belgium, Gallipoli and Mesopotamia. While some nurses were put on the lists for foreign services, essentially all nurses had to be willing to work night and day, at home and abroad. The VADs played an important role in freeing qualified, more experienced nurses for more demanding roles at home and abroad.

Specialist medical care at the auxiliary hospitals was provided voluntarily as needed by local doctors, and the Coronation Hospital continued to serve the medical needs of Ilkley people. In 1915, an isolation hospital was opened at Middleton for civilian tuberculosis patients, providing fresh air away from the industrial towns and cities in the district.

It was generally recognised that music and entertainment played an important role in raising the spirits of soldiers who needed some form of distraction from the monotony of hospital life. The soldiers in the military hospitals were given free admission to the 'Picture House' on The Grove and to the film shows at The King's Hall. The local schools

played their part. The log book entry of the National School in 1917 states: 'Ten wounded soldiers came into the boys' school on January 25th. The boys entertained them by singing some of their school songs. This, the headmaster reported was very much appreciated.'

A 'Soldiers Rest Room' was opened in the Church Institute on Leeds Road for recreation purposes. In October 1915, it was relocated to the Congregational Lecture Hall on Riddings Road to be closer to the hospital. Following an appeal, a billiards table was provided. There were various fundraising events supporting the work of the Rest Room, including concerts and shows in the King's Hall. The rooms had a piano and musical concerts were arranged. After the war, an article in the *Ilkley Gazette* gave an insight into one of the roles of the Rest Room: 'It is interesting to note that a few of the men in the local hospitals mixing with young women on special occasions admitted to the Rest Room, found in them not only sweethearts, but wives.'

Early in 1917, an urgent request was received from the War Office for additional accommodation to house increasing numbers of casualties. As a result, The Wesleyan Assembly Hall on Wells Road and the Congregational Lecture Hall were converted into further hospitals designated 'No. 2' and 'No. 3' hospitals respectively, although all three hospitals were under one administration and officially recognised as one hospital. These two hospitals together added a further 74 beds to the 100 already in place at The Grove Hospital. However, due to increasing numbers of casualties, the hospitals had to further increase the number of beds and, at its peak, the *Ilkley Gazette* reported that there was accommodation for 200 soldiers in the town.

The Wesleyan Assembly Hall became Ilkley's second Auxiliary Military Hospital as an increasing number of wounded British soldiers were brought to Ilkley. The foundation stones were laid in 1903, opposite the chapel on Wells Road, to provide extra facilities.

The congregational church hall, known as the Lecture Hall, opened as Ilkley's third Auxiliary Military Hospital in June 1917, taking the total capacity for wounded soldiers being treated in Ilkley to 200.

In June 1917, the Rest Room was transferred from the Congregational Lecture Hall to the Winter Gardens to make way for the expansion of the auxiliary hospital where it was based for the remainder of the war. The Rest Room closed in January 1919, along with the military hospitals, and the buildings reverted to civilian use. In April 1919, The Grove Hospital reopened to the public.

At the end of the war, the committee of The Grove Hospital received a sum of £850 from the military authorities in York to cover four and a half years of rent and 'dilapidation'. This left the hospital in credit and it was decided that the final balance of the money in the hands of the committee be divided among the local medical charities. In the years that followed, however, the hospital struggled to adapt to the new conditions. The hospital relied less on private subscribers and more on working people's hospital funds and social welfare departments. The local rate assessment for the hospital more than tripled after the war as local and national government were faced with the war deficit.

However, over the duration of the war, an estimated 3,200 patients were treated at the three military hospitals in Ilkley due in large part to voluntary efforts of local people. At the end of the war, the *Ilkley Gazette* reported that out of all of the patients treated at the hospital over the duration of the war, just four had died. The matron, Miss Mather, was awarded the Royal Red Cross for her work at the hospital in October 1917 and remained at the hospital until 1929. On the close of the military hospital, the *Ilkley Gazette* reported,

> The familiar figures of the 'boys in blue' will no more be seen amongst us. This purpose the hospital has served most admirably ... due to the most careful treatment and nursing, good management, and voluntary patriotic service of the noblest kind.

CHAPTER 6

THE CHANGING ROLE OF WOMEN

In the early years of the century, women had a wide range of identities and experiences; however, in general, their primary role was a domestic one in caring for home and family. Although some had taken on key roles within the community and many women worked in paid employment, the jobs available to them were limited and the vast majority were not allowed to take part in elections.

The Women's Social and Political Union, an organisation fighting for votes for women, had been formed in Manchester in 1903 with Emmeline and Sylvia Pankhurst as leaders. There was a strong following for the cause in West Yorkshire, and in the pre-war years rallies had been held in many towns including Ilkley. On 8 June 1908, Mrs Pankhurst and Adela Pankhurst had addressed a large crowd at a recruiting meeting at Ilkley Tarn. The *Ilkley Gazette* reported that it was a 'lively meeting' and that the 'Suffragettes were generally well received', although there were some interruptions consisting of 'bell tinkling, music hall ditties, penny trumpets and a bugle'. As time went on though, this campaign became increasingly militant and there were many opponents.

The following year, an Ilkley branch of the Anti-Suffrage League was formed at a meeting in Leeds. The aim of the league was to oppose the vote for women in parliamentary elections, although it did support women having votes in local government elections. This group was active in the town and, in 1914, Mrs Halbot from Leeds addressed the Ilkley branch in the Congregational Lecture Hall. At the meeting, she advocated the view that questions of housing, sanitation, nursing and hygiene came within the daily life of women and that they should aim for better representation on boards and councils to gain more practical knowledge of politics.

The debate continued. However, when war was declared, the national Suffragette movement, headed by Mrs Pankhurst, called a temporary halt to their campaign for the duration of hostilities. A nationalistic stance was advocated instead. Rival political groups agreed to put aside their political differences and women were encouraged to engage in the war effort.

Many of the traditional forms of employment for women, such as domestic service, catering and dressmaking were particularly strong in Ilkley as a residential town with a strong hospitality trade. Across the country, these domestic industries faced increasing hardships and shortages as the war progressed.

Another local group, the Ilkley Suffrage Society, were a group who aimed to achieve votes for women through more peaceful means. They immediately formed a Women's Employment Committee to help women dependent on sewing for their living to make garments to be sent to the Central Clothing Committee – a charity distributing clothing to the needy. In 1917, the national journal of the society, *The Common Cause*, reported that the Ilkley Society was honoured by a visit of the president, the suffragist Dame Millicent Fawcett, at a drawing room meeting given by Mrs Wood.

This group focused also on working with relief societies in the field of medical support. A hospital workroom was opened at the old council chambers on The Grove to make bandages and dressings for the Women's Hospitals for Foreign Service movement. Appeals were made for gifts of material, linen and muslin, as well as collections and sales in aid of the workroom. In contrast, the Anti-Suffrage League focused their attentions on work with servicemen's families associations and in organising support for the services by fundraisisng.

Each week the *Ilkley Gazette* printed appeals from many organisations from all strands of society. The Soldiers and Sailors Needlework Guild produced shirts, pyjamas, hats and socks and woven body belts to be sent to the front. It was strongly recognised that for the men at the front these were not just a reminder of home and what they were fighting for, but also a powerful morale booster. A further group of Ilkley ladies made sandbags to be sent to the front.

Many women worked as nurses with the local Voluntary Aid Detachment. Mrs Steinthal was given a room in the council offices to administer the work of these VAD nurses.

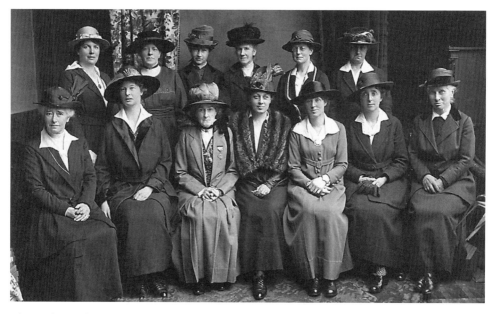

The Ladies Belgian Hospitality Committee was formed at a meeting at the town hall on 9 September 1914, chaired by Mrs Helen Rabagliati (*front row, third from the left*).

NURSE PARKER,
BRITISH RED CROSS SOCIETY.
LEFT ILKLEY FOR THE WAR NOVEMBER 6TH, 1914.

BELGIAN BABY
WHOSE LIFE SHE SAVED.

Above: Nurse Parker served at the Front with the Red Cross from November 1914 after working as a voluntary nurse at the Ilkley Military Hospital. On her departure from Ilkley, Belgian soldiers assembled at the station to shake hands, waving their caps as the train pulled out. This Belgian baby had been 'given up for dead', reported the *Ilkey Gazette*, 'but in the four weeks that she had it under her charge, gained nearly 5lbs in weight'.

Right: Studio portrait of gunner Norman Tennant and his mother, a Voluntary Aid Detachment nurse at the Ilkley Military Hospital, taken on his first leave in September.

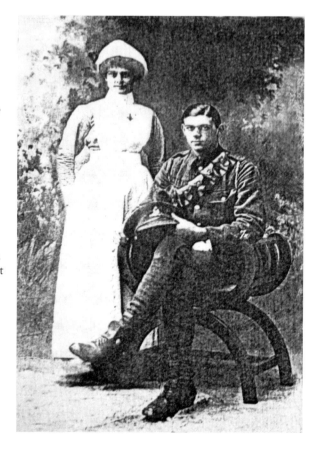

However, while the practical necessities of essential supplies and nursing care were being addressed, there was another group who took on a 'moral' crusade. The League of Honour was an organisation that had been formed in 1914 by Lord Kitchener under the banner 'Patriotism of Women: an organisation for women and girls of the British Empire during time of war', advocating that women show patriotism by abstaining from alcohol and acting as a good influence on soldiers.

In April 1915, the League of Honour held a well-attended patriotic meeting in the King's Hall, presided over by the wife of Sir J. H. Duncan, the MP for the Otley Division. The meeting was addressed by Miss Kitchener, Lord Kitchener's cousin and headmistress of the girls' grammar school in Bury. It was reported on by the *Ilkley Gazette*:

> Lady Duncan, in introducing Miss Kitchener, said this was one of the happy occasions when they could all meet together, in perfect accord, having one common interest in a bond of united sympathy. They were there that night as women of England eager to do their part to help their country in any way they could during this hour of need. Our men had gone forth to the defence of liberty and justice, and the women left at home could do much. They were fortunate in having upon the platform Miss Kitchener (applause) who they heartily welcomed for her own sake and also for the sake of her illustrious cousin.

The report continues with Miss Kitchener's address.

> Miss Kitchener said women's influence for good over men was very great. But if this were the case it must have its converse side. It was not only necessary to take a high platform for themselves, but it was also necessary not to stop at that; if they possibly could, to get to know some girl who might not have so high a standard. In some parts of England there was an extraordinary idea that members of the League of Honour were not allowed to speak to soldiers, but that this was not true. Friendship between a girl and a soldier ought to do the soldier nothing but good … She emphasised the great importance of the temperance pledge, and said that treating soldiers was one of the most wicked things that could be done. The man or woman who gave a soldier a drink was helping the Germans. If they dragged a man down either along the paths of impurity or intemperance, they were on the side of the Germans. She further referred to the need of prayer and urged those present to be steadfast, serious and strong. In this way they could be as patriotic as the men.

In towns such as Ilkley, where military men were regular and familiar visitors, there was concern about the behaviour of young women. This moral crusade assumed that it was the women rather than the men who should be upholding standards. As the war progressed, women became employed in a wider variety of work providing labour in roles often filled by men. Many women managed their husband's businesses, such as Charles Thackray's wife who ran Central Garage on the junction of Skipton Road and Bolton Bridge Road. Ilkley Grammar School at that time was a traditional boys'

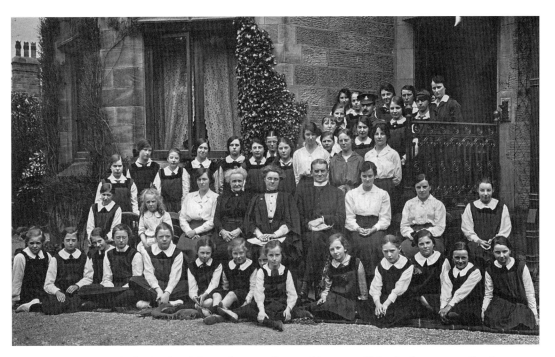

Empire Day at the high school for girls on Wells Road in 1915. Ilkley had many small private schools in the early years of the century. The school moved to this house named Annandale shortly after the turn of the century, but by 1919, it had closed. After 1949, it was occupied by the British Legion.

school. Several women joined the teaching staff temporarily to fill the absences of the masters who were on active service, yet it was not until the outbreak of the Second World War that the grammar school accepted girls as students for the first time.

Throughout the war, women were further encouraged to take up various kinds of work. In June 1918, an exhibition was held in the King's Hall to demonstrate the different kinds of work women were undertaking for the war effort. The exhibition included a consignment of shells made by the Phoenix Dynamo Co. from Thornbury in Bradford. The company Christopher Pratt & Sons, from Bradford, exhibited an aeroplane wing made by girls in their workshops, and there were various examples of steel and ironwork made by women at munitions training centres. Specimens of the different services were on view and a large number of photographs were hung on the walls illustrating women at work on the land, in munitions factories and at headquarters and depots of all sorts. In June 1918, the *Ilkley Gazette* reported:

Women are playing a big part in helping win the war. They may not have filled the trenches or manned the guns, but they have done a great deal towards providing the means of holding the trenches and using the guns, besides tending the sick and wounded, providing food and comforts for those who are fighting, and helping to carry on the ordinary business of the country in every way possible.

The work done by women during the war was a key factor in the granting of the vote for women on 6 February 1918, although this was only a partial victory for the campaigners since only those over thirty, married to a householder, or who held a university degree were eligible. Mrs Helen Rabagliati, who had been an active campaigner for improvements in conditions for women and political change, was quoted in the *Ilkley Gazette* as saying,

> Women had entered into an inheritance for which they had worked hard for many years, and it was now up to them to show they were worthy of it. It was a great responsibility that had been put in their hands, and they should use it well – not for party purposes, or their own purposes; but for the benefit of every individual and the whole country and nation.

CHAPTER 7

LIFE GOES ON

Entertainment and recreation, both on the home front and for those serving in the forces overseas, were considered vital by the government to help people endure the hardships and losses they faced, to keep up morale and to encourage a sense of normality.

In 1914, music hall was the most popular form of musical theatre and shows featured regularly at the King's Hall. One of the most famous music hall entertainers of her era, Miss Vesta Tilley, a male impersonator, brought her show to the King's Hall in August 1915. The show coincided with the holiday season and the *Ilkley Gazette* announced that the King's Hall was crowded in every part for this 'stupendous attraction'. Vesta Tilley's act featured impersonations of upper-class young men behaving badly. She also had a number of military characters.

For those serving on the Western Front, a concert party, The Tykes, had formed from soldiers of the 49th West Riding Division. The troupe had begun in a modest way on improvised platforms in the open air, providing entertainment for those serving in the forces. However, by Christmas 1915, they had become established as a theatrical company. By the end of the war, the party had performed in almost every sector of the Western Front, making a theatre of any barn, hut or schoolroom they could find. Between August 1915 and February 1919, they made over 80,000 francs for the 49th Division, which provided items such as portable bathhouses, instruments for the divisional band and 10,000 small tins of anti-frostbite grease.

In the *History of the 6th Battalion West Yorkshire Regiment*, E. V. Tempest described the 'eagerness to be amused, and to forget everything: the intense way the men took their pleasures' and the experience of the theatre:

> ... incredible luxury after the mud and horror of the trenches to come to the small theatre behind the line to hear good music and singing, and humour, often 'highly seasoned' and to see Lieutenant J P Barker arrayed in the latest robes from Paquin, showing a finely turned leg, shapely enough to have been the envy of a chorus girl at the Empire.

In the 1915 edition of *The Olicanian*, Bomber Richardson described a visit to the theatre:

King's Hall interior. The King's Hall opened in 1908 and was used for a variety of events including dances, plays and concerts. The Wharfedale Music Festival has met there since it opened. During the war, music hall and cinema shows were popular.

The performance lasted over 2½ hours and is given nightly by a pierrot troupe formed out of the 49th division. It is a splendid show and well performed. Price of seats 1 franc and ½ franc! It seemed very queer in a theatre about 6 miles from the front line and in the centre of a town, which the 'Allemands' frequently shell with their heavy howitzers.

The bathhouses provided by the proceeds of the Tykes concerts in turn provided a valued amenity for the soldiers. In his letter to the winter 1915 edition of *The Olicanian*, Bomber Richardson wrote:

We had a real joyride this afternoon to the Divisional Baths where we have a good warm spray. Twenty-seven of us went in an ammunition wagon, so you can guess what it was like – packed herrings indeed! ... As somebody remarked, 'It was like a Sunday School treat to Bolton Abbey Woods in a car-a-banc'.

The Tykes' concert party was encouraged by the military authorities since it had a positive effect on morale and wellbeing. Occasional official sports meetings were organised by the West Riding Regiment for the same purpose. One of the official sports meetings in France was held by the West Riding Regiment in April 1916 and

The Tykes' concert party were a highly successful pierrot group formed from soldiers of the 49th West Riding Division. They performed in almost every sector of the Western Front. In January and December 1916, they came home to West Yorkshire and performed at the Empire Palace in Leeds, the Opera House in Harrogate and the Empire Palace in Sheffield.

reported in *The Buzzer* magazine of the signals unit. To the sound of the Band of the 49th West Riding Regiment, the categories included various flat races, a sack race, an obstacle race, guard mounting, a relay race, mule race, band race and a tug-of-war presided over by Lt Col H. R. Headlam DSO, who acted as judge and presented the prizes.

The monotony of the long evenings for those serving on the Western Front was alleviated by musical entertainment, as Norman Tennant documents:

> Among the gifts that reached the battery in September 1915 were a gramophone from the late Commanding Officer of the Brigade, Colonel W Stopham Dawson. Concerts given on most evenings in the sergeants' mess-room at the billet were a great attraction.

The 49th divisional band visited the villages in which the men were billeted and the popularity of marching songs was on the increase. The song 'On Ilkla Moor Baht 'At' had been popular locally since around the 1880s, but it became more widely known

Col Dawson's Gramophone by Norman Tennant. In Autumn 1915, the Ilkley Howitzer Brigade received packages from the late commanding officer Col Dawson containing 'one of the best hornless gramophones, 62 double-sided records of a popular character, brush for dust and an ample supply of needles'.

during the war as it was used as a quick march song by the men of the Yorkshire Regiment and then picked up by others. In 1917, the *Ilkley Gazette* referred to an article that had been printed in *The War Illustrated* about the various refrains, chants and songs sung by soldiers at the front

> remarking that the following quaintly humorous song and refrain is sung by men of the Yorkshire Regiments to the hymn tune 'Cranford'[sic] ... The writer, who is evidently not a Yorkshireman, explains that the words of the refrain mean in English 'On Ilkley Moor without a hat.'

The song 'On Ilkla Moor' is actually sung to the tune 'Cranbrook' by Thomas Clark, not to be confused with *Cranford* – a novel by Mrs Gaskell in 1853.

Back in Ilkley, The King's Hall was also home to a very different form of musical entertainment in the form of the annual Wharfedale Music Festival. This had been running since 1906 and it was felt that it should continue during the war since it had an important educational role as well as the value of music in hard times. The *Ilkley Gazette* reported:

> The war is far-reaching in its disastrous effects, and many organisations and institutions have suffered as a result. Not so the Wharfedale Music Festival, however, which not withstanding all the war means in terms of sacrifice, suffering and loss, can boast an increased number of entries in many classes ... the fact that music, both on listeners and performers alike, acts as a nerve tonic ... With war at present always the nightmare of one's vision, preparing for and attendance at the Festival might for many relieve a good deal of strain and tension which war obsession inevitably produces.

The festival proved hugely popular, and it continued to be held every year throughout the war and has met at the King's Hall annually since.

In 1914, cinema was a new and exciting form of entertainment. At that time there were two venues showing films in Ilkley – the King's Hall and the Picture House on The Grove. The Grove Picture House had opened in February 1913. The cinema seated 728 and, at that time, performances were continuous from 6.30 p.m. until 10.30 p.m. every evening, except on Saturdays where there were two evening performances and

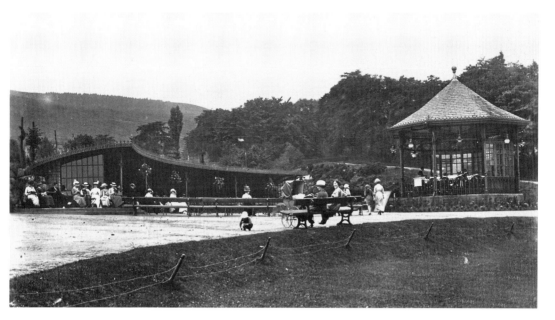

Bandstand, West View Park, *c.* 1916. The bandstand had been built in 1904 as part of the drive to establish Ilkley as an inland resort in a small park at the top of Wells Road. In the following year, a covered seating area was provided. The bandstand was demolished in 1948 and the adjacent shelter in 1954.

a matinee. It survived until 1968 when it was demolished to make way for part of the central car park along the back of The Grove.

At the King's Hall, cinema equipment had been installed in 1910. At the end of June 1914, films had ceased to make way for different musical shows but film showings increased rapidly in the early months of the war. Feature films were rare at that time, but the programmes featured many short items such as comedies, dramas, travelogues and newsreels with live musical accompaniment. From the beginning of September 1914 there was one show a month at the King's Hall, but, by the early part of 1915, there was generally a show at least three nights a week.

At that time film was a relatively young media. However, the government realised the power of film in controlling the war news. On 21 August 1916, the film *The Battle of the Somme* was released by the War Office. This was a groundbreaking British documentary film now accepted to be an early example of film propaganda, as well as a historical record of the battle. On 14, 15 and 16 September 1916, film footage of the start of *The Battle of the Somme* was shown in Ilkley. For the audience to see images of the war as it was happening unfolding on the screen was a profound experience, quite unlike the melodramas and comedies to which they had become accustomed. The reviewer in the *Ilkley Gazette* described the experience:

> Nothing like it has ever been seen before, is the general verdict, and this is certainly true in that it depicts many of the most thrilling and terrible incidents in the greatest war of all time. One sits literally spellbound watching these incidents unfolded on the screen with a vividness and reality that is wonderful. First one beheld the activities before Fricourt, Mametz and Picardy, where our own lads in the West Ridings, West Yorkshires and several other regiments did glorious work, and some lost their lives. Hidden batteries had been pounding the German trenches, the local Howitzers assisting, and shrapnel and high explosive shells were seen bursting over the enemy's trenches and causing terrible destruction. A bayonet charge was a thrilling scene, and also the blowing up of German trenches by a huge mine. To see these pictures once is not sufficient, many have stated, and this is true. There are so many incidents and things of interest crowded into the film that after several views, something new is still revealed.

Further battlefield films were made about the battles of Ancre and Arras, but they were less popular. Actually seeing the men in these horrific situations was a profoundly moving but difficult experience for people to watch. Increasingly, audiences looked to the cinema for escapism and entertainment.

Sporting activities were also a key leisure pursuit. Before the war, there had been increased emphasis by the government in encouraging physical fitness and the spirit of sportsmanship engendered. After the outbreak of war, however, many local clubs found it impossible to continue due to many of their members serving in the forces.

In 1914, a record entry was recorded for the annual tennis tournament. However, in 1915, it was decided by the Lawn Tennis Association that the tournament should be suspended for the remainder of the war. The cricket club continued playing in 1915, but, as twenty-seven of its members were by then serving in the forces, it was decided

KING'S HALL, ILKLEY.

THURSDAY, FRIDAY & SATURDAY,
SEPTEMBER 14, 15, & 16.

THE BATTLE OF
THE SOMME,

BY PERMISSION OF THE WAR OFFICE

Doors open at 7-30.
Commence at 7-45.

MATINEE SATURDAY AT 2-30.

SATURDAY—TWO SHOWS—6-45 & 8-45.

PRICES:
1/-, 9d., 6d., 3d. Boxes 7/6. Plus Tax.

———

NEXT WEEK—'THE CHRISTIAN.'

Advertisement for the film *The Battle of the Somme* in September 1916. This film remains one of the most watched films in national cinema history.

to stop play for the remainder of the war. In 1916, the cricket field was given over to the production of hay. When the harvest had been gathered by August, the ground was available for charity matches to be played, although the Ilkley tradesmen's annual cricket match known as the 'Black Hats and White Hats', which had been played every year since 1880 (apart from 1902), had been cancelled in 1914 and did not resume until 1920.

For those serving abroad, sporting activities provided not just a means of recreation and a physical outlet, but also a powerful cultural influence and a reminder of home and happier times. Perhaps even more valuable as a morale booster was the *esprit de corps*. Surplus cricket tackle from local clubs and schools was sent to men serving in France, and a letter of thanks from Sgt C. E. Dove was printed in *The Olicanian* in summer 1915: 'We were all delighted when the bats, wickets and balls the boys sent out to us came yesterday.'

Due to a shortage of ammunition, the Ilkley Territorial Battery, known as D245, had a relatively quiet time at the end of May 1915. After settling the guns in a field near Aubers Ridge, the diaries of the unit describe how the tackle sent from Ilkley was used: 'Across the road, behind the position, there was a large field surrounded with tall poplars, and here many an afternoon was spent in playing cricket, with tackle sent out from Ilkley.'

As well as cricket, many other sports were played by the men serving abroad, including football, swimming, athletics and horse riding. Sometimes these sports were officially organised but more often, they were played on an ad hoc basis.

The identification of sport and gamesmanship with military endeavour was at its closest during the First World War. In particular, the game of rugby had embodied the idealistic, masculine, patriotic ideal that was encouraged in training young men to be leaders of the empire. At the first monthly meeting of the Yorkshire Rugby Union after war was declared, a letter was issued to all their clubs recommending

> all football in the county be suspended during the continuance of the war, and we strongly appeal to our players to join some unit for the defence of the country. The Yorkshire Union confidently believe that every eligible player of theirs will place himself at the disposal of his country at this crisis.

Rugby was popular with the Ilkley and Otley territorial units, who had many excellent players as well as a number of Yorkshire County team representatives. In the diaries of the D245 Ilkley Territorial Battery, Sgt A. E. Gee wrote: 'It was a boast of the Brigade in the early days that a Brigade team would give a good game to a team selected from the rest of the British Army.'

Unfortunately, some of these matches resulted in injuries. On 29 January 1916, the Brigade was billeted near Arneke. It was a time before the intense preparations for the Somme had begun in earnest for the Ilkley Battery. Norman Tennant wrote in his diary:

> I was persuaded to play in a rugger match between the sections ... It was a wild rough and tumble affair and I felt very stiff afterwards. This was followed next day by a match between the Brigade officers and men in which the Medical Officer dislocated his leg.

However, as the war progressed, rugby took second place to football. This was the services game, a game that all men could play and it also roused fierce competitive instincts. On 2 April 1916, as the preparations for what was later realised to be the Battle of the Somme increased, Norman Tennant wrote in his diary,

> ... as it was Sunday we played our sister battery at soccer but lost 2:1. The traditional rivalry between Otley and Ilkley must have resulted in some rough play as one man in the opposing team had his arm broken.

On the home front, one sport that continued in Ilkley throughout the war was golf, despite calls for the course to be utilised for war purposes. Ilkley Moor Golf Club had started work to extend the course from nine to eighteen holes in 1913. Despite the outbreak of war, the work continued and was completed in 1916. Throughout the war, Ilkley remained a resort town and visitors continued to stay at the hydros and hotels. The proximity of the moorside golf club provided an added attraction.

Following the outbreak of war, Ilkley golf club allowed men in uniform who were members of golf clubs elsewhere to play free of charge. Visiting army officers in the area were given honorary membership during their stay. In 1916, out of the total

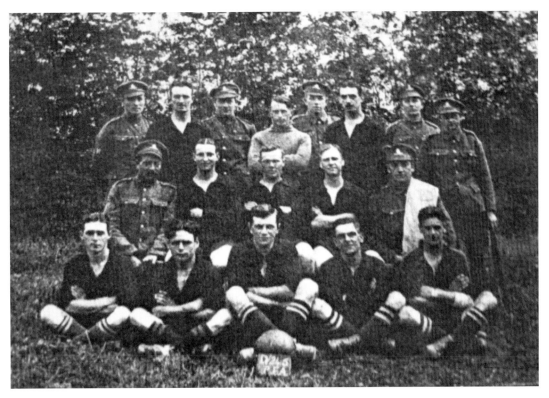

Ilkley Howitzer Battery football team in France, 1918.

membership of 305, it was estimated that some 30 men were serving in the forces. By the end of the war, this figure had increased to 60. In 1916, the special constables were given permission to practice drill on the course one evening a week.

Sheep had been used on the course for many years before the war to help to raise revenue and to help to keep the grass under control. However, this had caused complaints about the mess, especially on the greens. Bowing to pressure, the committee had decided to exclude the sheep from the course for a twelve-month experimental period from June 1912. John Saywell records the outcome:

> ... as a consequence, it became necessary to hire an extra horse and three or four extra men for about a month to deal with the abnormal growth of grass. Much time was wasted, much temper and many balls were lost, members refused to come, visitors went away disgusted, receipts fell off and the Committee became the target of considerable criticism. The long grass had brought a cry for the sheep to be brought back, although in practice they did not eat the very long grass.

The committee decided to bring back 150 sheep due to the high cost of mowing. However, in order to minimise the damage to the greens, the sheep were penned in at night. This resulted in the farmers objecting to the deterioration of the sheep and

asking for compensation. John Saywell records the response from the committee: 'All were agreed that the scorch marks spoiled the appearance of the greens but there were differing opinions on whether they had any effect on the putting.'

In September 1917 when food shortages took a hold, after long discussions, the club concurred with the agricultural committee of the Wharfedale District Council. Rather than ploughing up certain parts of the course, it was decided that twenty-five head of cattle could be fed on the course in addition to 300 sheep. As a further help to the war effort, the club used 16 acres to produce hay and members of the club helped with harvesting.

Another activity which continued in times of war was swimming. The grammar school had opened a swimming bath in May 1913 – still in use today. Norman Tennant, an ex-student of the school, regularly recorded in his diaries from the Western Front the value of swimming, both as a way of keeping clean and as a recreational activity. On 21 June 1916, just ten days before the first day of the battle of the Somme, he wrote:

> Our chief pleasure here is bathing in the Ancre, which flows gently past about 50 yards behind the lines of gun pits and dugouts. The river is only 6 feet wide and what a delight it is on these hot days to swim upstream a little way and then float down with the current hidden from a mad world by the high bank on one side and Martinsart on the other ... German planes are very active watching our preparations and we saw several fights as our machines arrived to drive off the intruders.

The Battle of the Somme, which started on 1 July 1916, was a major turning point in the war. After this, conditions and attitudes changed irrevocably. However, it was acknowledged by Norman Tennant in his diaries that the team spirit helped the men through what was to come: 'There was a friendly rivalry with other neighbouring Territorial Units, which inspired a team spirit that was to be so valuable in the coming years.'

CHAPTER 8

THE HOME FRONT

From the onset of war, fears of a possible invasion were increased by the naval conflict in the North Sea. The war came to the east coast late in 1914 when the German Navy turned their guns onto Hartlepool, Great Yarmouth, Scarborough and Whitby. The opportunity for propaganda and recruiting was not missed on either side. Recruiting posters were produced with the slogan 'Remember Scarborough. Enlist Now.'

On the outbreak of war, a wave of anti-German feeling swept across the country fuelled by government propaganda. In Keighley on the day after the outbreak of war, there were riots in which four German pork butcher shops were wrecked. In Bradford, groups of naturalised Germans signed letters expressing their desire to see Britain victorious. Despite having British naturalisation, people having a German name often found that their social standing, positions and businesses changed almost overnight.

At the time of the Howitzer's departure, an officer from Ilkley, Capt. Steinthal, received a promotion to the rank of Major. By September 1915, the *Ilkley Gazette* reported on a Maj. P. C. Petrie among the ranks of the Battalion, and this evidently caused some confusion. The situation was later clarified by the newspaper:

We understand that the Major Petrie referred to in our last issue is not a new addition to the Howitzers, as many have supposed. He belongs to one of the best-known Ilkley families and has been in the Brigade for some years. He has simply adopted his mother's maiden name, who, we believe, is one of the representatives of a well-known Lancashire family.

The Ilkley Society of Friends were supportive of those who found themselves victims of the wave of nationalistic fervour because of their names. Mrs Bohlman wrote in an article entitled 'Quakers in Ilkley':

In 1914, residents in England with a German name, whether they were Germans, Austrian or nationalised British had cause to be grateful indeed for the loving care bestowed on them by Friends at a time when a Central European name alone laid them open to internment, violence or at least ostracism, especially from the less educated.

Ilkley Railway Station. The railway had opened in 1865 by the Midland Railway and the North Eastern Railway.

Thomas Wakefield held the important post of Ilkley stationmaster between 19 March 1904 and 22 October 1924. His position is embroidered on his lapel.

Ilkley Friends, though not all absolutionists in their attitude to the peace testimony, responded very generously and sympathetically to opportunities for such caring.

The Defence of the Realm Act (DORA) had been passed in August 1914 and it governed every aspect of life in Britain during the course of the war. It gave the government wide-ranging controls, including the power to requisition land or property and to make regulations creating criminal offences. It imposed strict controls, including censorship of journalism and of letters coming home from the front line. The aim of the law was to support the military campaigns overseas, keep morale high, and to prevent invasion of the country.

Towards the end of 1914, a local volunteer force was formed in Ilkley, comprised of men who were ineligible to join the armed forces. Initially, such volunteer brigades were officially unrecognised by the army, but they became accepted as a valuable contribution to the defence of the home front. The volunteers trained in drill, shooting, 'bombing tests' and anti-gas practices, as well as route marches and athletics. The company was based at the Drill Hall, with the title West Riding Volunteers, 20th Battalion.

Early in 1915, the Kaiser had given the order for Zeppelins to be sent to attack strategic targets, despite the fact that they were very expensive to build, difficult to control and accuracy of the bombing was poor. They continued in various forms throughout the war and although the total number of casualties was relatively small, the menacing bulk and droning sound had a profound psychological effect. The total blackouts caused increased tensions and anxieties to the civilian population, as well as limitations to production.

In February 1916, a blackout was enforced in Ilkley to avoid it becoming either a target or a navigation aid. All street lights were turned off and a warning siren was installed at the electricity works to be sounded in the event of a threat from the air. Residents were informed that the police, fire and ambulance services would be on hand. They were also advised to turn off the gas in their homes in the event of the air raid warning being sounded. It was ordered that 'not more than a dull, subdued light is to be visible in any direction'.

Zeppelins were hard to see at night and they cruised at high altitudes out of the range of many ground-based guns. However, there were some successes in shooting down the airships and the hydrogen explosions could be seen from far afield. In November 1916, a Zeppelin was shot down at Durham. This was allegedly seen in Ben Rhydding over 80 miles away. The following report appeared in *The Ilkley Gazette* of 1 December:

An Ilkley North Eastern Railway engine driver states that he saw the burning Zeppelin which was destroyed off the Durham coast on Monday night, or at any rate, the flare resulting. Mr Buttershaw of Ben Rhydding, according to the *Yorkshire Evening Post*, states that the glare in the sky caused by the burning Zeppelin, was seen from Ben Rhydding. He and three friends were standing on the railway bridge when a bright glare suddenly illuminated the far distant sky in a north-easterly direction.

It seems almost incredible that the flare could be seen from such a distance, but one theory is that light from the explosion may have reflected off high cloud about halfway between Ben Rhydding and Durham. In January 1919, following the lifting of censorship, the story of a Zeppelin's visit to Wharfedale was printed in the *Ilkley Gazette*, illustrating how close the area came to an air attack:

> This occurred on Monday, September 25th, 1916, when a fleet of seven German airships came over the North Sea intent on doing all the damage and causing all the 'frightfulness' possible. Just about midnight, the Zeppelin was seen at Ripon, but it missed the big military camp and unshipped five bombs in quick succession close to the village of Wormald Green, all dropping in open fields.
>
> It hovered over Harrogate, which was in pitch darkness, and then glided off towards Harewood, dropping a bomb on the way in an open field near Weeton. Reaching Harewood Park, incendiary bombs were dropped one after another in quick succession, but none did any damage, although Harewood House which was being used as a Red Cross Hospital, came very near to being blown to pieces.

The *Ilkley Gazette* received a fair amount of mail on the subject from people who could elaborate further on the incident. It is not clear how many airships were in the vicinity. In the newspaper of the following week, a further article about the raid was published:

> Many Ilkley people remember the night of Monday September 25 1916 with anything but feelings of pleasure, for the bursting of the bombs in the Harewood district could be distinctly heard by those who happened to be up when the extinguishing of all light indicated that an air raid was in progress and the explosions had such a terrific atmosphere disturbing effect as to rattle windows of many Ilkley houses ...
>
> At the time of the visitation, we were told that the Zeppelin visited Bolton Abbey and dropped a bomb in a meadow, which failed to explode ...The sound of the Zeppelin's engines was said to have been heard by people in Ilkley and Addingham, and an Addingham man who mentioned this the morning after the raid still holds this conviction. On the occasion of another Yorkshire air raid, the airship brought down in flames on the Yorkshire Coast could be seen descending to its doom from the railway footbridge leading from Railway Road to Springs Lane.

In the space of just over two years, the story about the Zeppelin shot down seems to have become somewhat embellished, and the sighting moved from Ben Rhydding Bridge to Ilkley. It was later believed that the aircraft commander may have mistaken the River Wharfe for the Aire. In the German version of the raid, published at Berlin, it was claimed that Leeds had been bombed. On 25 and 26 September 1916, at the time of the airship over Ilkley, it was later documented that Bolton and parts of East Lancashire also came under attack by Zeppelin raids. On 27 November 1916, there was an attack on Leeds, which was repelled by anti-aircraft fire.

Early in 1916, a new incendiary bullet had been developed that could be fired from British fighter planes to set fire to the gas in the airships. A leading supplier of aircraft to

the British Government during the First World War was the Blackburn Aeroplane Co. based in Leeds, founded by aircraft construction pioneer, Robert Blackburn. Between the summer of 1913 and 1914, the Blackburn Type 1 – a two-seated aircraft – was demonstrated extensively through Yorkshire by demonstration pilot Harold Blackburn (no relation to Robert Blackburn), who visited localities that had seen little or nothing of flying.

The first recorded aeroplane over Ilkley appeared on the evening of 11 June 1914, piloted by Harold Blackburn. It drew people out into the streets.

In August 1916, another aviator was recorded in the *Ilkley Gazette*. By this time, pilots were becoming bolder.

> An airman has twice flown over Ilkley lately, and in a meadow on the Addingham Moorside, he has each time alighted. The aviator is said to belong to Ilkley; but be this as it may on Wednesday afternoon he provided a very fine spectacle by looping the loop twice in flying over the town. At one point his machine seemed to be just skimming the house tops and those on the lookout could see the aviator distinctly.

These early test pilots took great risks and became heroes to many people. On 17 May 1917, a fatal flight was made by test pilot William Ding, who also worked for the Blackburn Aeroplane manufacturer in Leeds. After looping the loop, the wing came off the aeroplane and he tragically crashed to his death near Oakwood Hall in Bingley.

The total blackouts caused by the air raids and the instruction to turn off the gas supply meant that candles would have had to be used since the lighting for many people at that time was gas. The electricity works had opened in 1915, but electricity was still an expensive form of power for ordinary citizens.

The electricity works were built on a central site next to the gasworks at the junction of Little Lane and Lower Wellington Road, opposite Clifton Terrace. Construction of the works had begun in October 1914, but, due to government demands, it was found to be increasingly difficult to obtain the materials required. The engines and generators had been commandeered for war service. Finally, two generators, each with a capacity of producing 100 kw, were supplied by the Phoenix Dynamo Co. Ltd of Bradford.

Critics of the electricity scheme had questioned the wisdom of building the works at that time, but representatives from the council had pointed out that the commitment had been in hand before the war had started, and that to leave the project unfinished, would result in still having to pay interest on their loan.

On the grand opening of the electricity company, Mr Dixon, the chairman of the Electricity Committee, addressed the assembled crowd from a raised platform evidently near the boiler. The *Ilkley Gazette* reported that this was 'about as warm a place as any of them are likely to be associated with in an official capacity this side of the grave'.

Another plan that was pushed ahead, despite wartime difficulties in obtaining materials, was the 'trackless tram' service. Before the war it had been proposed to link Otley to the Leeds city tram terminus at White Cross, Guiseley, by means of electric trolleybuses. Burley was included in the scheme, and it was further suggested to link Ilkley as well, but there was an element of objection from some of the local traders,

who felt that by undercutting the train fares people would be induced to visit Leeds via Guiseley and thus reduce trade in Ilkley. In the event, when the 'trackless trams' started in September 1915, they stopped at Burley. In the late 1920s, with the increasing development of the conventional bus service, this trolleybus service was withdrawn, although the trams between Guiseley and Leeds remained in use until the 1950s.

Throughout 1915, many men came forward to enlist with the armed forces. Those that did not were not under any legal compulsion to do so. However, there was a strong moral pressure exerted on such men – often referred to as 'shirkers'. In February 1916, with the passing of the Military Service Act, conscription became compulsory for all males between the ages of eighteen and forty-one. Those who presented reasons for claiming exemption from service were sent to a local tribunal who judged on the validity of the case.

In Ilkley, a tribunal of council and military representatives sat in the council chamber in the town hall. Some applications were rejected outright. Others were deferred for a month or two, and then conscripted, usually on the grounds that replacement workers had to be found to fill their position. Some applicants were of a physically weak disposition or ill – usually these were exempted. Other applicants claimed their aged parents would face destitution in their absence. Some were 'conscientious objectors' who believed that war was morally wrong. Some of these were put to serve in non-combative roles such as local ambulance services instead.

Generally though, excuses for not wanting to fight were not tolerated and the application for exemption was refused. At an adjudication hearing in Ilkley in May 1916, there was an application for exemption from an antiques shop proprietor. Maj. Welch, the military representative sitting on the panel, suggested that if the applicant closed his shop 'his stock would become still more antique.' To another applicant it was suggested that his sister might look after his shop in his absence, to which the man replied, 'she can't sell a pennorth of tacks!' Other traders appealed on behalf of their staff, claiming destitution if their lads were sent away. These appeals were generally refused, and female staff recommended instead.

Between February 1916 and November 1918, the Ilkley tribunal heard many cases to be considered for exemption. These included 168 where exemption was granted, 117 where the application was postponed and 120 where the applicant was refused. Additionally, there were a few cases where the application was withdrawn.

As the war continued, the pool of men of fighting age still at home dwindled. To counter this, the upper age limit was increased to fifty-one. This immediately made thousands of men available for service, and kept the tribunals busy with considering more exemption applications. An increasing number of exemptions or postponements were allowed. Often older men, particularly tradesmen, had lost their younger staff to the forces and were finding it hard to keep their businesses going. Sometimes their appeals found favour with the board and they were allowed to remain, such as milkmen, who were part of the daily supply chain, while others were signed up regardless, such as chimney sweeps, where it was considered that Ilkley could manage with only a few.

To add to the increasing tensions of the civilian population, by May 1915 there were serious shortages of food and raw materials caused by blockades. The navies needed to keep the oceans free for the movement of their armies and supplies. In February 1915,

the Allied navies announced a blockade in order to prevent supplies from reaching the Central Powers of Germany and Austria-Hungary, and Germany declared the seas around the UK to be a war zone.

The *Lusitania*, a luxury British ocean liner, was one of the world's fastest passenger ships, launched by Cunard in 1906 at a time of fierce competition for the North Atlantic Trade. On 1 May 1915, the *Lusitania* left New York for Liverpool. On 7 May 1915, she was torpedoed by a German submarine and sunk 11 miles off the southern coast of Ireland with the loss of nearly 1,200 lives. The use of submarines in firing on a non-military ship was against international law. It caused outrage around the world, particularly in America, and there were calls for America to join the war.

A well-known former Ilkley resident was on board. Mrs Stones and her husband were returning from Vancouver to visit her mother Mrs Joy, who had a baby linen shop at No. 33 Brook Street for many years. Before the disaster, the German Embassy in the US had placed a newspaper advertisement warning people not to sail on *Lusitania*:

> ... friends in Ilkley had received intimation that Mrs Stones intended to cross on the Lusitania, but it was hoped that the threat to sink the vessel would have deterred them from doing so ... As Mrs Stones was so well and affectionately known in Ilkley, the terrible tragedy through which she met her death, is a very personal calamity to many amongst us.

By the end of 1916, 738 merchant ships had been sunk by German U-boats, destroying many thousands of tons of food supplies. There were real fears that unless the situation altered significantly, Britain could be forced to surrender due to starvation. In December 1916, a Central Food Controlling Authority was formed to secure food supplies, keep prices down and increase cultivation. Voluntary, and later compulsory, rationing was implemented as a measure to preserve stocks.

By 1917, the national food supply was under increasing strain. Although food was being grown and the Women's Land Army were working hard on farms, the country relied on imports as well. 'Community Kitchens' were introduced around the country. Food could be cooked in large quantities and distributed at reasonable charge, with the aim of saving food and fuel as well as providing economies of cost and labour. However, this was considered by some to be a form of charity. The *Ilkley Gazette* was at pains to dispel this notion in the report of the opening of the Ilkley Community Kitchen in the church institute on Leeds Road in June 1917:

> There are those amongst us who view with anything but favour efforts of the well-to-do to help those less favourably circumstanced, though kitchens of this sort are in no sense a charity or benevolent institutions, but designed only and solely to help the country in respect to the food problems.
>
> Ridiculous as it may appear, there were those who thought the scraps of meat and bones from the larger houses would be utilised for soup making, and one man was heard to say that he was not going to send his bairns to feed on any man's leavings. No need to have any fear of anything being done here savouring of some charitable

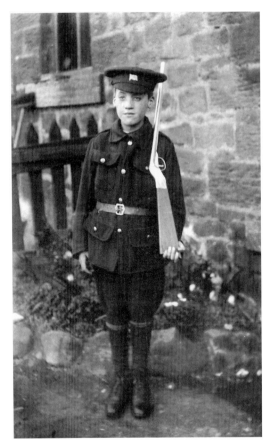

Above left: In the early stages of the war, it was not uncommon for children to be dressed in miltary uniform as a sign of patriotism, to encourage fundraising or as mascots for the troops. This is Charlie Hunnebell at the back of his home in Wellington Road.

Above right: Advertisements for Ellis Beanlands' shops on Bolling Road, Ben Rhydding, and on The Grove.

soup kitchen practices, as all the meat and produce used is absolutely fresh, and purchased from local trades people, with the intention of giving as many of these a turn of patronage as possible.

The kitchen had started on the opening day by providing a dinner for fifty people consisting of pea soup (1*d*), rice pudding (1*d* and 2*d*), cottage pie (3*d*) and vanilla mould (1*d* and 2*d*). No food was served on the premises and purchasers had to take their own jugs and basins. The Ilkley Council supplied gas for cooking at cost price.

Altogether 141 portions of food, varying in price, were sold on the opening day, and as many more could have been disposed of if the food had been there ... even the workers had to go dinnerless, so far as the kitchen was concerned. Many had to go

away without securing a mouthful of anything, and some of these schoolchildren whose mothers had been relying on the youngsters obtaining there dinner here.

A solution was found in that orders were sent across to the kitchen from schools and orders from families were reserved in advance.

By March 1918, there were 300 allotments in Ilkley and available land such as the grammar school field were given over to vegetable crops. There were appeals for more people to grow vegetables as well as to keeping pigs, poultry and rabbits. Despite the food shortages, however, local people continued to send food parcels to those serving with the forces at the front. Norman Tennant wrote in his account of his experiences with the Ilkley Howitzer Brigade on the Western Front:

As the year 1917 moved painfully through its depressing course, the morale of the Allies reached its lowest point of the war. The never-ending slaughter on all fronts, the defection of Russia and the mounting success of the U-boat campaign against our merchant ships was reducing this country to near starvation and yet, somehow, parcels from home continued to be scraped together – at what heights of self-denial we, at the front never knew … What magnificent morale boosters these surprise packets were! One in particular I remember was a huge fruit cake soldered up in a specially made tin container.

All Saints Church Institute on Leeds Road was used as a communal kitchen providing cheap and nutritious meals. Later it became a school dining room for All Saints School.

A street cleaner is filling his water cart at a hydrant at the bottom of Brook Street. Street cleaning was vital, especially following the military parades involving horses. However, the cart was requisitioned for war use in 1914.

By 1917, after three years of war, soldiers and civilians were pushed to the limits of endurance. The local news by 1917 was dominated by sad news of local men killed, wounded or missing in action. There were very few letters, interviews or personal accounts.

Facing food shortages at home, the men of the highways and scavenging department of the Ilkley District Council came out on strike in May 1917. Their application for an increase in wage of 1d per hour had been turned down, although they were granted an additional war bonus of 2s per week. The men were getting a minimum wage of 23s 9d a week. The request was made because many men in other towns were getting more. However, the *Ilkley Gazette* reported that,

> quite a large percentage of the men employed in this district are 70 years of age or over, and it is not to be expected that they can compete with strong able bodied men usually employed in the large towns.

It was felt that older men were required to do the same work and consequently there were less wages to go around. The six stokers at the gasworks supported their council colleagues and demanded an increase of 6s a week – giving a week's notice to leave if they were not to receive it. It was eventually agreed that a rise of 2s a week would be granted by the Ilkley Council, which the workers accepted.

In January 1918, there was another round of industrial action by the council workers and gas stokers over pay. The strike caused the gas supply to be cut off in the town between 8.30 a.m. and 4.00 p.m., and 9.00 p.m. and 6.30 a.m.

The No. 2 Military Hospital in the Wesleyan Sunday School premises used gas for both cooking and lighting, and so the soldiers were transferred to the military hospital on The Grove where part of the cooking was done using fire ovens and the rest done externally. The communal kitchen was also forced to close until the strike was eventually resolved by arbitration. The men returned to work in March with their pay backdated to December 1917.

CHAPTER 9

CHRISTMAS

Christmas at home and abroad provided a time when the war could be set aside, if only for one day. The customs of the festive season – peace and joy – were at odds with the situation that the citizen soldier found himself in. However, it was a powerful symbol of traditions before the war and brought thoughts of home and family along with gifts and parcels from home. The military authorities recognised the importance of boosting morale at Christmas and plentiful food and drink was provided for those 'at rest' behind the front line, along with sports and entertainments.

Early in the war, there was a sense of optimism. It was widely believed that it would be over by Christmas. Even when it became apparent that this would not be the case, there was still a sense of hope that it would be a quick, honourable contest. Albert Denison, a despatch rider with the Motor Transport Section of the Army Service Corps, wrote a letter printed in *The Wharfedale Observer* in December 1914:

> I get the *Wharfedale* paper all right and it is very nice to read a paper from home ... Next week we are going up to the firing line again and then we are able to have a rest. We carry ammunition etc ... I wish we thought we were going to be home for Easter. That will tell you what we have to do. If the war finished by Christmas we could not get back sooner, but every man is living in good hopes of being home for the summer holidays.

In Ilkley, Christmas was quietly observed, although the hydros remained popular throughout the war with seasonal visitors. Fundraising activities continued. The Soldiers and Sailors Needlework Guild collected £50 in funds from local sponsors. Some 360 local men serving in the forces received a 'quarter pound tin of Cope's Bond of Union tobacco and a box of 50 Chairman cigarettes' in a box, with the message 'Christmas greetings from your friends in Ilkley and Ben Rhydding. We are proud of you.'

Soldiers from the Ilkley district serving on the front report that Christmas Day 1914, for their battalions at least, was a quiet affair, with little in the way of hostilities. However, the bombardments came back with a vengeance in the days following. Cpl W. Sheard of the 6th Siege Battery Royal Garrison Artillery, writing to his mother, said,

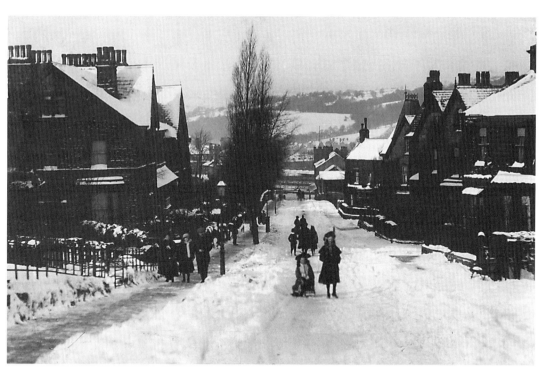

Snow on Cowpasture Road *c.* 1920. In Christmas 1914, it was reported that snow fell in Ilkley. A tea party was held in the King's Hall for 600 family members of those serving with the forces. Carol-singing was held by the Orpheus Glee Union, accompanied by the brass band. In 1917, a snowfall in April was considered a possible result of artillery action in France.

We are having some awful weather – cold winds, rain and snow. But we keep smiling; also fighting. I read the account of your tea party in the King's Hall and was pleased you enjoyed yourselves ... Well now for a bit of our Christmas. I must say we spent it grand under the circumstances. The officers in our battery had a surprise for us. They gave us all a stocking. Mine contained cigarettes, matches, chocolate, oxo, and a pair of socks. Then we all got a Christmas card from the King and Queen, also a box from Princess Mary containing smokes, a pipe, her photo, and a Christmas card. We had roast pork and pudding for our dinner, so we did well, and as the Germans never fired a shot all day that made it a bit better, though they have made up for it since. We have got into a house now to sleep. I suppose this will be our winter billet, I hope so as we have made it very comfortable. We have got a piano and all sorts of things here, and have a sing-song when we have finished firing. It does pass away the time these long nights. It would be awful without something like this. I was in bed at 5.30 pm on Christmas Day, also on Boxing Day, as I cannot stick the cold now. (The *Ilkley Gazette*)

Christmas 1915 was the first the Ilkley Territorials experienced in action. A. E. Gee wrote in the diary of the Battery:

Our Presentation Box for the Troops!

Specially Papered and Packed, containing

Sent by Post Free U.K.

5/-

XMAS CAKE,
PLUM PUDDING,
6 MINCE PIES,
HAM PIE,
BOX CHOCOLATES,
CRACKERS.

See Our Windows.

A. W. WHITAKER (Successor to M. A. VAUX) Confectioner,

Tel. 7. The Grove, Ilkley.

Advertisement for Christmas boxes for the troops in 1915.

The shops in Poperinghe wore quite a festive air, and all kinds of things were purchased there. Masses of silk-worked postcards had been sent home, bearing the flags of the Allies in colours, and seasonable inscriptions on them. Parcels had been received, one for each man, from the people of Ilkley, containing delicacies that were unobtainable in Pop., and lots of lucky men had private ones from home. Tinned plum-duff was the chief item at both places, and quite a few bottles of champagne were broached.

At the wagon lines, Captain Watson organised a cheery sing-song in the evening ... At midnight a party of serenaders went round the lines from hut to hut, whereupon the flowing bowl flowed with renewed vigour. The discomforts of the past faded, and the future took on a bright hue, until the effect wore off. In the messes and the billets, not to mention the gun position itself, those at the gun lines had their Christmas cheer, and mightily enjoyed themselves.

In Ilkley, the seventy wounded soldiers at the military hospital received a bag containing an apple, an orange, tobacco, a box of Cadbury's chocolates and a Christmas card from the ward sister, with a traditional dinner provided by Albert Illingworth who lived at Denton Hall. Some of the able patients walked around the town in the afternoon, wearing paper hats from crackers. There was a whist drive and, in the evening, singing and dancing. During the week following, the ladies connected with the soldier's rest

room, along with the local Girl Guides, provided a tea in St Margaret's Hall. 'There was an uncommon sort of repast for the menu, selected by the men, it included fried fish and chip potatoes, liver and bacon and muffins and crumpets. In addition there were sweets and crackers.'

By 1916, the war had taken a heavy toll and many more local men were away from home – through joining up or conscription. Christmas was more subdued as the *Ilkley Gazette* reported:

> Some attempt was made at Christmas observance in most homes, and spice cake and cheese and mince pies seemed as much in evidence as ever, with something to wash the 'good cheer' down, even though this amounted to nothing more than a 'drop o' peppermint'.

The logistics of getting the parcels out to the men on the front by the Post Office was a massive operation. While some had to wait for their parcels, others made the most of an early delivery as the *Ilkley Gazette* reported:

> Those who happened to be at base, resting, or under training in the camps at home, spent a very enjoyable Christmas, but some of the Ilkley men in the trenches received no Christmas parcels, and all they had for Christmas dinner was bully beef and biscuits.

At Christmas 1916, the Ilkley Territorial Unit was at Lucheux in France. A. E. Gee wrote,

> Christmas was at hand and preparations to celebrate it were duly made. The Christmas dinner, splendidly prepared by the cooks, was served in a large estaminet in the village, and the whole Battery except essential duty men, sat down at tables groaning with roast pork, plum pudding and rum sauce, with sweets and other indigestibles. The Officers and NCO's served the meal and for a change ran about at the beck and call of gunner and driver. After dinner a jolly smoking concert followed and the divisional commander dropped in for a moment to wish the battery a Merry Christmas. In the evening as many as desired went to hear 'The Tykes' our most excellent concert party playing in the village. Champagne again after the show, in the estaminet, and a visit of the Battery en bloc to the Officer's Mess to serenade the Major and the others, terminated a 'bon' day ... So ended the second Christmas in France, and the third since mobilisation, and from them all, peace on earth had been conspicuous by its absence.

Norman Tennant wrote in his diaries that after church parade and dinner, there were songs, speeches and toasts, not forgetting the momentarily hushed one 'to absent friends'.

In 1917 Christmas was very quietly observed in Ilkley. The editor of the *Ilkley Gazette* observed,

Christmas card from the 49th West Riding Division, 1916. Above the main image on the right of two infantrymen, fully equipped for fighting, is the Yorkshire white rose. Inside the card is the image on the left of a dejected German soldier.

If for some it was a time of sorrow rather than joy of any kind, the many soldiers home on leave from the Front and training centres made it a time of rejoicing for others ...

Despite all the war means to us in the way of food shortage, turkeys, geese, poultry, meat, fruit and most other things much in demand at Christmas were plentiful, if dear, and in most households a Christmas dinner was provided much the same as in ordinary times.

Christmas letters from those serving with the forces were printed in the local press, but unlike in previous years names were not given, and for the first time, letters from women serving were reproduced. A woman serving in France as a nurse with the Voluntary Aid Detachment, on the gift of a collection from Ilkley people, wrote,

I shall be delighted to spend the 10 shillings on some of our patients, when they arrive. We are having a very strange Christmas right away from everywhere. Everything is

Christmas card sent in 1917
by the 62nd West Riding
Territorial Infantry Division –
nicknamed The Pelicans.

unfinished. We are in huts, and seem to feed mostly on bully beef and biscuits, but we
are a cheery crowd, and hope to shake down in time.

In 1918, the armistice had been signed only six weeks before Christmas, and therefore
it was logistically impossible to demob and return home all of the men serving with
the forces. Some men, however, were lucky enough to be at home on furlough over the
festive season, and some displayed a rebellious attitude to the prospect of having to
return to their units:

In the homes where reunion with their men folk on service was one of the pleasures
afforded, there was naturally a spirit of much jollity; the men on furlough both from
depots, training centres and overseas, being much more numerous than at any time
during the war ... A few of the men on leave were due back on Christmas Eve and
Boxing Day, but whether they all returned to their depots or ports of embarkation on

XMAS CARD, 1918
49TH (WEST RIDING) DIVISION.

Christmas card, 1918, from the 49th West Riding Division. The card is decorated with the badges of Yorkshire and Lancashire regiments.

the dates named we very much doubt, for one man we spoke to said he would see the Army [damned] before he would go back on Christmas Eve, and when told he might get the sack remarked with a grin 'No such luck!

Food shortages were still taking their toll. While geese, turkey, duck and poultry formed the main part of the Christmas dinner, dried fruit and apples were scarce and there were very few iced cakes.

For those still serving, this would be their last Christmas together. In January 1919 the *Ilkley Free Press and Addingham Courier* printed extracts from a letter from an Otley man:

Half a pig was bought at three shillings and sixpence a pound. Christmas pudding, issued by a generous government, arrived in good time (for once). Vegetables,

cigarettes, cigars, fruit and beer, were found somewhere, and we were sure our luck had turned when a French baker offered to roast our pork, and a supply of holly and mistletoe was forthcoming.

An officer made a speech:

Remember this is our last Christmas we shall spend together. Next year we shall have finished with khaki, and be with our wives and families. Our only regret is that so many of our old comrades have answered the last call. We have been lucky and we want to make this Christmas one to remember for the remainder of our lives.

CHAPTER 10

VOICES

During the First World War, the written word flourished through letters, diaries, and poetry. Letters were the main means of communication between families and friends at home and abroad. Although correspondence from the front line was censored, letters often give a better sense of the conditions and mood of the times than the newspaper reports, which were strictly controlled by government and military authorities. Families shared letters with the press, especially early in the war.

The Olicanian of Ilkley Grammar School printed letters and articles from 'Old Boys' serving in the forces. The headmaster on the outbreak of war was Corbett Wadsley Atkinson who corresponded individually with all who wrote to the school. 'The arrival of the post bag is the day's great event' wrote Islay Ferrier Burns, a prominent contributor to *The Olicanian* while serving on the Western Front. In December 1915, Mr Atkinson died suddenly at forty-five years of age. His death broke a strong bond with the school for 'Old Boys' serving in the forces.

The early letters in the newspapers and *The Olicanian* reflect youthful enthusiasm and innocence. As the war went on, the gulf widened between what was actually happening and the jingoistic way it was reported at home. The old concepts of responsibility, duty, honour and self-sacrifice paled as the terrible losses and suffering took their toll. In the aftermath of the war, there was an unwillingness to talk about events and experiences as people adjusted to the losses. It wasn't until 1931 that the history of the Ilkley Territorial Unit, *A Record of D245 Battery 1914–1919*, written by Sgt A. E. Gee and Cpl A. E. Shaw, was published. Most of the history was compiled from diaries:

> No private ones could be kept officially, with the natural result that most men kept one of a sort unofficially ... in February 1917 they were given up as irretrievably lost when they were buried deep under the debris of the Sergeants' Mess after an 'OK' on it by a 'Boche' 11 inch HE [High Explosive]; it was due to a few good friends, who put in days of tremendously hard work with pick and shovel, that they were ever recovered.

One of the earliest letters from a serving soldier to be printed in the local news was from Cpl W. Wood from Burley who had served in India with the Duke of Wellington's

The *Olicanian* magazine of Ilkley Grammar School, Autumn 1916. The magazine started in 1900 and it continued until 1971. During the war, it was published termly and printed letters and news items from ex-students in the forces from all over the world. The headmaster, Mr Atkinson, who died suddenly in December 1915, was succeeded by Mr Frazer who remained headmaster until 1933.

Regiment. Before the war, he had worked for Payne & Sons printers in Otley. As a reservist, he was called up on 5 August 1914 to join his regiment. As the company were crossing the channel, he wrote a letter home:

> Tell the children I am a soldier, and have my duty to do, and I hope to do it to the best of my power. Tell them they must not think, but pray for me as a true British soldier. Our brigade is known throughout the world as the Terrible 13th, so I am very proud to belong to it.

Cpl Wood died at Mons on 24 August 1914 – the first battle fought by the British Army in the First World War. His death was reported in *The Wharfedale Observer*:

> Corporal Wood leaves a sad home, a widow and five young children mourning his loss. 'Killed in Action' will always come to them with a shock of tragedy. But at least they will know this: that it was the death of a husband and father doing his duty.

In contrast, this letter printed in *The Olicanian* in spring 1915 from a young Robert Cobby in training at Bisley Camp sums up a sense of youthful exuberance:

So far we are learning the innards of the machine guns and are at present shooting on the ranges. This is great fun and the first experience of sitting behind these guns as they spit out 100 shots a minute is most curious. And what a glorious din!

Robert's younger brother Monty Cobby had also enthusiastically taken up the call to arms. *The Olicanian* of winter 1914 proclaims,

Well done Cobby (Monty)! The last boy to leave the School and the first at the Front! Rather than wait a month or six weeks for a Commission he enlisted as a regular in the R.G.A. [Royal Garrison Artillery] and was on his way to the 'Firing line' in a very short time. All Olicanians are thinking of him and wishing him a safe return.

Both Cobby brothers survived the war and in 1919, the grammar school magazine reported that 'The Brothers Cobby intend to take up the army as a career.'

In May 1915, a letter home was printed in the *Ilkley Gazette* from Norman Tennant, another grammar school 'Old Boy' and the first injured in action of the Ilkley Howitzer unit, wounded near Aubers Ridge:

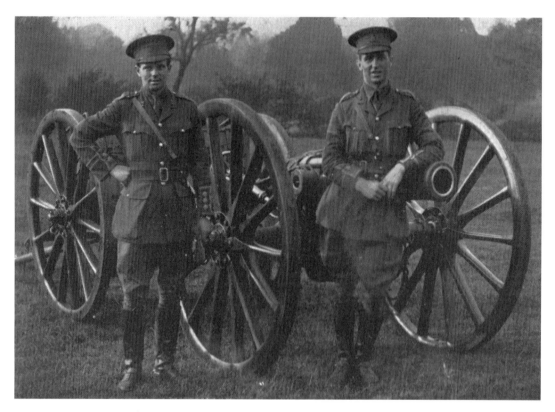

Maj. P. C. Petrie and Capt. J. H. Eddison (later lieutenant). Both officers went to France with the 11th West Riding Artillery Battery. Maj. Petrie acted as commanding officer of the Ilkley Battery during the whole period of hostilities.

The Poor Duty signaller and Lieutenant Eddison. Sketch by Norman Tennant (a signaller with the Ilkley Howitzer Brigade). Lt Eddison had been a student at Ilkley Grammar School between 1901 and 1904. He had played international rugby for the England team in 1912.

We had quite an exciting time yesterday, and I was wounded by a shell. It was a glancing blow, and just took a bit off the top of my head. Our artillery opened about four o'clock in the morning to cut the wire entanglements and prepare the way for our advancing infantry. The din was terrific, and I was one of the telegraphists at the observation station which was about 1,000 yards away in front of the battery. I could see our shells bursting in the German trenches about 400 yards away. It must have been fearful there, and when we had finished there were no German trenches left. It was more like a ploughed field.

The poor beggars dropped in dozens, and amongst the steady stream of wounded which passed us there were some ghastly sights ... At the time I was hit I was standing at the door when a big shell landed in the middle of the road about eight yards off. It blew me back into the house from which we were observing. I consider myself lucky to get off with a mere scalp wound, for the same shell killed a Cameron Highlander who was standing outside, and took four fingers off the hand of another chap.

Norman Tennant kept a scrapbook of news cuttings after the war (now within the Liddle Collection at Leeds University). He later scribbled over this youthful commentary, 'This is terrible!!!', and under another he wrote, 'The complete immaturity of these letters reflects the conditions of a time when extreme youth suddenly found itself in a vast new experience. I still blush with embarrassment when I read them.'

Peter Liddle, of the Liddle collection wrote in the book *Voices of War*:

When the British cheered the coming of war in August 1914 ... they truly did not know what they were in for; they were 'innocent' indeed. This was to be their first encounter with major war in the industrial age, the age of mass populations, the mass armies and the mass casualties, and it would be shocking. But we must be clear about our meaning: not shocking in the sense of sudden revelation; this shock was cumulative.

A sad loss for the battery occurred on 1 September 1915 when Capt. R. T. Benn was killed at an observation post near Boesinghe on the Ypres road by an enemy shell. A. E. Gee wrote,

> The older hands well recollected his energy in turning out Church Parades in Ilkley, and the care he took to see that all details of the smart full-dress uniform were correct. His parting words, before the Battery marched off and the Band struck up, used to be 'Heads up, chests out, and swank like blazes', and swank we did in those halcyon days.

Norman Tennant wrote,

> I had my first leave of five days soon after and I was given the sad task of taking his personal effects to his home in Burley. What a strange experience that leave was; so strange in that all the familiar places seemed so different – it was, of course, I who

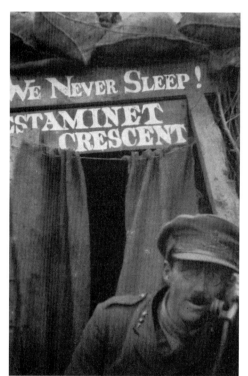

Capt. Joseph R. T. Benn of the Ilkley Howitzers at a telephone dugout at Richebourg St Vaast, April/May 1915. The trench here has been named Estaminet Crescent. The phrase 'We Never Sleep!' refers to a shortage of signallers at the time. Sadly, on 1 September 1915, Capt. Benn was killed by a shell at an observation post near Boesinghe while observing fire on Pilkem Ridge. He was laid to rest by fellow officers and men the following day at Tahuna Farm on the Boesinghe –Ypres Road.

Roy Cowling was one of the two men at the head of the parade of Kitchener recruits known as 'Pride of Ilkley on the March' seen in Chapter 2. The other man, Maj. Lansdale, was injured twice during the war. Roy Cowling was sadly killed in August 1915 while apparently looking over a trench parapet at a flag the Germans had put up in front of their trench.

had changed. One day spent in travelling home and another for the return journey left a mere three days into which to pack so much. Messages from my friends to their families took part of the time and the rest was just being at home with its comforts and joys. Sitting in easy chairs gave one the sensation of falling, so used had we become to 'hard lying'.

Another grammar school boy and prominent contributor to *The Olicanian* was Islay Ferrier Burns, also known as 'Tam O'Shanter, the school poet'. In winter 1914, he wrote, 'I am longing for the day when I can join the forces.'

In May 1915, Islay Burns sailed to France with the 10th Battery of the Motor Machine Gun Service, 9th Division BEF (British Expeditionary Force). He wrote to the school, 'Behind, all that we hold dear and near; in front, a desolated country, a ruthless foe and our good pals, the "contemptible little army."'

The small army of the BEF that went to France in 1914 was supposedly scornfully called a 'contemptible little army' by Kaiser Wilhelm. The soldiers quickly dubbed themselves 'The Old Contemptibles'. While the nickname certainly boosted morale, no evidence has been found that the Kaiser used this phrase, and it is widely believed now that the story was a fabrication by the British War Propaganda Bureau to sustain the war effort.

In *The Olicanian* of summer 1915, an article was printed by Islay Burns that included his first impressions of trench life: 'in this trench we stayed hours, and in that time we were the preys of three sensations: 1/excitement 2/indifference 3/boredom'.

In May 1916, another substantial article by Islay Burns was printed. In the heat and squalor of the trenches, he daydreams about a school cricket match while smoking a pipe:

> The stink, ever present and everywhere pervading of the sun on garbage, waste and decay, fills the air and those beastly big bloated bluebottles buzz round in shaking shifting squadrons or crawl, hundreds and hundreds of them, about the trenches. They are not forced to live and die in these sandbag labyrinths that cut and mar the countryside, they are not like sheep awaiting the butcher, their blue green bodies are not targets for invisible death...
>
> I sit down in the trench bottom and get my pipe alight. Far away to the left the guns growl like distant thunder; to the right, shrapnel shells burst and whine around a biplane whose pale pegamoid wings shine like gossamer in the fierce sunlight. But just here all is quiet except for the occasional sharp crack of a sniper's bullet winging overhead...
>
> With eyes half closed I daydream and conjure up visions in the curling blue cloud ... The field green and freshly mown is alive with white clad figures ... From my eyrie in the scoring box the various activities are easily seen, but it is on the white flannelled cricketers near at hand that I must rivet my attention. By jove! It is hot up here! I envy those chaps the slight breeze that fans their flushed faces and makes their loose shirt-sleeves flutter...
>
> I am a youngster yet – not 20 but whether I die tomorrow, the next day or not for years and years, the best time of my life will ever have been my schooldays up in Yorkshire.

In September 1916, Islay Burns returned to England to train for a commission. He went to France again in May 1917 with the 97th Machine Gun Corps and then to Nieuport where the British battalions were overwhelmed after heavy fighting. In autumn 1917, *The Olicanian* reported, 'It is with a feeling of the deepest regret that we report the death of 2nd Lieutenant Islay F Burns MGC better known as 'Bobbie' killed in action on July 11th 1917, somewhere near Nieuport.'

His commanding officer wrote, 'He was in command of a section of machine guns and during an evening attack was shot through the heart, I think with a revolver. He died instantaneously and can have suffered no pain.'

In spring 1918, a further letter was received by Mrs Burns giving a new appraisal of events:

> From letters seen after his death, it was evident that they suffered terribly before the end. He was burned, buried, gassed and wounded during that time. His body was seen by two officers but, as later in the day that bit of trench was taken, they could not bring him in, though three attempts were made to do so. Islay was carrying a box

2nd Lt Islay F. Burns of the Machine Gun Corps. *The Olicanian* describes him as: 'A clean living, healthy and intelligent fellow; a veritable Hercules in strength and on the rugger field posessed a stone wall defence.' Islay Burns was killed in action in July 1917, 'somewhere near Nieuport'.

of ammunition and one of his men killed beside him, the tripod of a machine gun they were setting up. He was just where the danger was greatest and where there was special need.'

A crude but menacing form of warfare was gas. On 19 December 1915, many Ilkley men serving with the Duke's and the D245 Battery had been caught up in one of the early phosgene attacks at Brielen, an hour before dawn. Norman Tennant described the experience:

We were wakened up by a terrific bombardment of the trenches ... my throat was caught up by the choking vapour which was curling about outside. 'This is it', I thought, and the first panic reaction was to take to my heels anywhere to get away from this evil insidious cloud which crept slowly and silently over the ground with the slightest movement of wind. My cry of 'Gas' brought the others from their beds and then followed a feverish hunt for gas masks ... Pulling the foul thing on I buttoned up my tunic to enclose the skirts of the hood and pushed the mouthpiece into my mouth. It was horrible not to suck in any air through that and I thought I would never be able to breathe through the thick flannel but eventually I found that the foul thing worked.

The result of the phosgene gas attack was that nearly a half of the Infantry of the 49th West Riding Division were put out of action. A. E. Gee wrote, 'Those who saw the gas casualties said that the spectacle of these men, struggling to breathe, with livid faces and froth-flecked lips was terrible.'

From January 1916, the 49th were put 'in rest' – the first period of complete rest that the division had experienced since April 1915. On 3 February 1916, the Ilkley Battery were moved to the village of La Chaussee, on the hills near Picuigny overlooking the Somme Valley. A. E. Gee described the area as, 'The district hereabouts was reminiscent of Wharfedale. Steep hills towered on either side of the valley, covered with trees, white villages of white-washed houses, dotted here and there, glittered in the sun.'

On 1 July 1916 at the battle of the Somme, it is estimated that there were approximately 60,000 British casualties, of which nearly 20,000 were deaths. Whole communities of young men, many from the Pals battalions of Kitchener's Army, were wiped out, devastating communities. A. E. Gee writes,

> The morning of 1 July 1916, a date which will never be forgotten was misty and warm ... The battery was firing a steady programme of barrages, ending at maximum range ... it was hard to realise as we sweated in the gun pits, that thousands of our infantry had just gone 'over the top' on a front of over a dozen miles, that every sunny minute saw men looking their last on the world they knew, and that hell was let loose just over the wooded knoll in front ... All the world now knows the result of that first days battle of the Somme, and how the ridge on which Thiepval stood proved to be a mass of fortresses and redoubts. Further left, in attacking Gommecourt Wood, the Leeds Pals had suffered terrible casualties ... The effect of the first day on the Battery was a general feeling that things had somehow gone wrong, and there had in some way been a fearful catastrophe.

The Leeds and Bradford Pals – the 15th and 16th West Yorkshire Regiments respectively – suffered severe losses near the fortified village of Serre causing shock and disbelief as news of the disaster filtered home. As the men went 'over the top' in waves they faced the German Maxim guns and the uncut barbed wire. This was the first experience of any real fighting of the 17th West Yorkshire Regiment, the Leeds Bantams, who had trained at Ilkley and also suffered heavily. In summer 1916, the editorial of *The Olicanian* summed up the general mood at home: 'The end of this term has brought us to a new phase in the war, and with the aggressive movements of the British forces comes the news of many casualties among our old boys.'

Following the Somme, the fighting continued relentlessly. A. E. Gee wrote, 'For three and a half months the Battery had fired by day and by night and had taken part in barrages or special shoots for large attacks and small ones nearly every day.'

In February 1917, visits were paid to friends in the 62nd West Riding Division, the second line, at Lucheaux, which had recently arrived from England. By 1917, things were particularly bleak. In the words of Norman Tennant,

The year 1917 was the blackest period of the whole war when morale reached its lowest ebb. The useless slaughter on the Somme with so little to show for it, the steady drain of trench warfare with no end in sight ... There were rumours apparently all too well founded, of mutiny in the French Army, the increasing success of the German U-boats in almost bringing the country to starvation by sinking an ever-rising tonnage of our merchant ships, brought much suffering and hardship to the people at home, a fact made only too obvious when we went on leave and saw the effect on our parents.

In May 1917, Norman Tennant recorded a chance meeting with another 'Old Boy' from Ilkley Grammar School:

Strolling around the lanes this evening, as we sometimes do, I met Eric Wilkinson, now a Captain in the West Yorkshire Regiment. When I was a mere fourth former at Ilkley Grammar School he was a prefect and school captain and very prominent in sports, school plays and other activities.

Eric Wilkinson had won the Military Cross in 1915, when he was a lieutenant with the Leeds Rifles, for bringing in wounded under fire at Brielen. He had served in the trenches near Ypres from winter 1915 when he was wounded by a bayonet and gassed. In July 1916, he was again wounded in the attack on Thiepval. After spending time in hospital in Chatham, he returned to France where he was gassed and his sight permanently damaged. He had been made a captain before the attack on Passchendaele Ridge.

Eric Wilkinson died on 9 October 1917 at Passchendaele Ridge. He was one of the many men who died leading the first wave of the attack. Years of shelling had turned the area into a swamp. The battle had been fought under impossible conditions and there were heartbreaking casualties. Eric Wilkinson's death is recorded in *The Olicanian* of autumn 1917: 'Amid the sea of mud he became separated from his men and was last seen making single-handed for the enemy lines.'

In 1915, the headmaster of Ilkley Grammar School, Mr Atkinson, had sent the school rugby match list to Eric Wilkinson in Flanders as a reminder of school. On receiving the card, Eric Wilkinson took some comfort in the vivid memories conjured up by and wrote a poem printed in *The Olicanian*. An extract is reproduced below:

> The sand-bag bed felt hard.
> And exceedingly cold the rain,
> But you sang to me, little green card,
> And gave me courage again.
> For at sight of the old green background
> And the dear familiar crest,
> I was off and away, on memories track
> Where Rombalds Moor stands bleak and black
> And the plaintive curlews nest ...

Capt. Eric Fitzwater Wilkinson MC, 8th West Yorkshire Regiment. He excelled both in sport and academically. After studying engineering at Leeds University, Eric Wilkinson had returned to Ilkley Grammar School as a junior master. Before the war, he had published *Sunrise Dreams and Other Poems*. On 9 October 1917, aged twenty-six, he was killed in action at Passchendaele Ridge. There is a memorial plaque to Capt. Wilkinson in Ben Rhydding Methodist church.

There's a broad green field in a broad green vale,
There's a bounding ball and a straining pack;
There's a clean cold wind blowing half a gale,
There's a strong defence and a swift attack.
There's a roar from the 'touch' like an angry sea,
As the struggle wavers from goal to goal;
But the fight is clean as a fight should be,
And they're friends when the ball has ceased to roll.
Clean and keen is the grand old rule,
And heart and courage must never fail.
They are making men where the grey stone school
Looks out on the broad green vale.
Can you hear the call? Can you hear the call?
Now, School! Now, School! Play up!

CHAPTER 11

THE END OF THE WAR

At 11.00 a.m. on 11 November 1918, church bells rang across Europe. The fighting was over, but life would never be the same again. Millions had died around the world and those who returned home had the hard task of making sense of the horrors they had survived and readjusting back to civilian life.

The Ilkley Howitzer Brigade brought the guns into action for the last time on 10 November at 2.00 p.m. at Quevy-le-Grand, unaware that the last day of the war was so close. A. E. Gee recorded the events of the morning of 11 November:

A mounted staff-officer in a big hurry, passing by with wild news of the Armistice, was thought by many to be a spy; but the Major fired with his own hands a single farewell round at top range at 9am – the safety cap being left on the shell to prevent accidents at the other end of its journey and it began to be realised that all was about over bar the shouting. Shortly came instructions that the Armistice at 11 o'clock was official; and the men stood about as this moment approached almost expecting some sign from Heaven. This came from the heavens at a quarter to eleven in the form of a dozen German shells into the village in front – with the safety caps off. Other Batteries concealed in hedgerows and banks all about could be heard firing their parting shots also ... While most of the world went mad to celebrate the Armistice, it is noteworthy that the men who had most immediate occasion had least opportunity for celebration. Though the fact of the Armistice was known, it was certainly not fully assimilated at first, and the momentum of routine and discipline carried the battery through the next few days without any changes to indicate that its *raison d'etre* had vanished and that this body of men which had worked for years as a single compact unit to a single end was about to split up into 200 distinct and separate individuals, striving after their 200 private ends ...

On 11th November 1918, a pointed salient formed the British Front at Valenciennes. The West Riding Artillery was at the apex of this salient being the most advanced Divisional Artillery, and D245 Battery prides itself on that, so far as can be ascertained, no British Battery of Artillery was nearer to Germany when the war ended than itself.

In Ilkley, at 11.00 a.m., Mr Dobson displayed the news on a blackboard outside his newsagent and tobacconist shop on Brook Street with the addendum 'official'. In a short time, the streets became very lively. The *Ilkley Gazette* reported,

> There were flags of all kinds and streamers too, not a single street being noticed without some evidence of jubilation. Many of the flags had done duty on other occasions of rejoicing than the present, and the 'Welcome Home' that one bore in large letters will still more fittingly serve to welcome our local warriors spared to return.

Wounded soldiers at the Ilkley military hospitals, taking possession of a tradesman's cart, rode round the town in merry mood. Later, a larger group that included soldiers and sailors at home on leave, broke into the Volunteer Bugle Band room in Bridge Lane, and secured a number of drums and one or two bugles. To the accompaniment of these, they paraded around the town. In the afternoon they were joined by some of the volunteer buglers, and paid a visit to Addingham with one of the wounded soldiers dressed up to represent Britannia. The *Ilkley Gazette* described events:

> With such a holiday spirit in evidence, a good deal of the business of the town was suspended at midday, and a number of the shops closed. The Parish Church bells were rung both at noon and in the evening, and the Volunteer Bugle Band continued to peregrinate the town in the evening after the wounded soldiers were obliged to be indoors. The youngsters had the time of their lives, and although the National Schools continued to open in the afternoon, there were many absentees. As night closed in upon the scene fireworks began to be let off in all parts of the town. The pyrotechnic display in Brook Street was of a character never before attempted; nor would it have been allowed. D.O.R.A. and the police were not to be met with in authority, and squibs, crackers, rockets, maroons and Roman candles mingled together in blazes of light and noise for several hours .The thanksgiving services held at the Parish Church and St Margaret's church were very well attended.

The signing of the Armistice, which gave way to relief and rejoicing, was tinged with great sadness at the loss of life. An editorial in the *Ilkley Gazette* summed up the situation:

> The curtain has finally rung down on the greatest and most terrible war in the world's history. The glad tidings were everywhere hailed by the Allies with the greatest enthusiasm; indeed more than was to be expected, with the knowledge of the desolation the war has caused and the sorrow it has brought into so many lives. If there was momentary forgetfulness of this on the part of any, it was to be forgiven; for how could the majority of people keep in check their feelings of thankfulness on such a day. Yet not all rejoiced in boisterous and hilarious fashion, for a much deeper and more sober thankfulness was shown by some in attendance at the thanksgiving services held throughout the length and breadth of the land.

The Olicanian of winter 1918 starts with the sad announcement that at the close of the war, the grammar school had a longer list of fallen than in any term during the previous four years: 'They include every generation of 'Old Boys' from Norman Muller, who came to us in 1895 to Eric Cornwell, who left only last year.'

The total commemorated on the Roll of Honour is sixty-six former students. These were among the boys who had been educated at the school between 1893 and 1917. However, many of the former students had moved away from the district, therefore not all of those who died in the war are recorded. An appeal was launched for £350 for the memorial – a lectern in the school hall carrying the names of those who died. This was designed by Frank Brangwen and unveiled in 1920 by Mr Swann, the first headmaster.

Every man who risked their life in the service of their country was a hero, but some acts of bravery and selflessness resulted in the award of the Victoria Cross, the highest military honour for bravery. Capt. Thomas Harold Broadbent Maufe of the Royal Garrison Artillery was awarded the VC at only nineteen years of age when he was a second lieutenant. He was later promoted to captain. The *Ilkley Gazette* reported,

> Under intense artillery fire this officer on his own initiative repaired, unaided, the telephone line between the forward and rear positions, thereby enabling his battery to immediately open fire on the enemy. He further saved what might have proved a most disastrous occurrence by extinguishing a fire in an advanced ammunition dump.

In 1919, the *Ilkley Gazette* informed its readers of what had become of the 17th West Yorkshire Regiment or the Bantams from Leeds who had been billeted in Ilkley in spring 1915. Their first experience of fighting was at the Somme, later in the various sectors including Arras. The Bantams suffered heavily. Many honours fell to men of the battalion; two of them, Sgt Mountain and Sgt Butler, won the VC. Both men survived the war. They are commemorated on the Victoria Cross Memorial outside Leeds City Art Gallery and Library.

There are many rolls of honour at work places, clubs, churches and sporting institutions around the district. The rugby club was severely affected by the losses and the secretary of the Yorkshire Rugby Football Club Union in his annual report of June 1919 said,

> In presenting this report, it is difficult indeed to dwell upon the sad happenings and the ghastly tragedy of the last five years without the deepest and most heart-searching feelings … Meanwhile, it is the duty of this meeting to pass a vote of condolence to the soul-anguished relatives of those boys who have fallen, and also to tender our deeply grateful thanks to all those who have come safely through this ghastly world war.

The armistice that had been signed in November 1918 was the first step in securing a more permanent peace. Although hostilities had at that point ceased, with the signing of the Treaty of Versailles in June 1919 the peace became official. To mark this, the government planned national celebrations to take place on the weekend of Saturday 19 July.

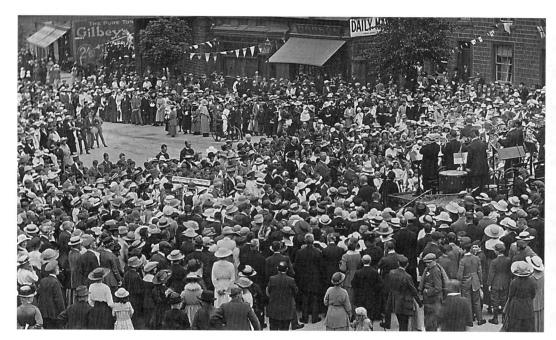

Peace celebrations, 19 July 1919. Mr Sidney Kellett of Middleton Lodge, who had organised tea for the children at their Sunday schools, addressed the crowd at the top of Brook Street. Children and their parents sang hymns at the top of Brook Street to music provided by the Municipal Orchestra.

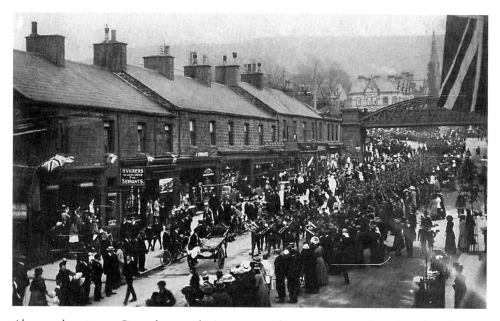

Above and next page: Peace day parade. At 3.00 p.m. there was a procession of Sunday schoolchildren and the newly returned soldiers. The parade marched down Brook Street and over the New Bridge. This was followed by sports and games on the Holmes fields and a firework display.

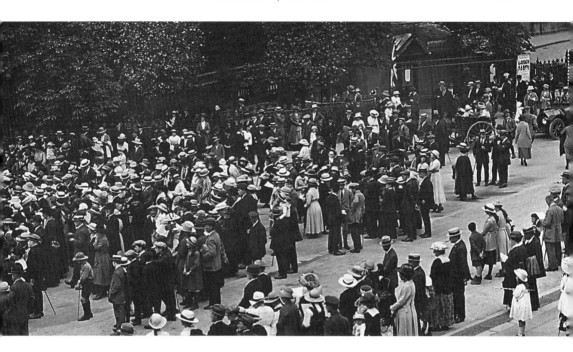

In Ilkley a large crowd gathered at the top of Brook Street to see the Sunday School's children's parade. The newly returned Ilkley Howitzer Brigade, led by Maj. Petrie, marched from the town hall to the gathering and was greeted 'amid a storm of cheering'. Mr Sidney Kellett of Middleton Lodge, who had organised tea for the children at their Sunday schools, addressed the crowd. The band played 'On Ilkla Moor Baht 'At', and cheer after cheer rang out as they passed along the route, for this was the first opportunity for a public welcome home to the men of Ilkley.

The celebrations continued on the Holmes field, with sporting and musical entertainments. The evening was brought to a close with a firework display, while on the moors, a beacon had been lit. At the electricity works a large crown had been erected in electric lights, and gave a very vivid display. *The Ilkley Free Press* reported, 'Good humour, usually marked with a quiet restraint, but which occasionally welled over into a burst of abounding happiness was the keynote of the well-arranged festivities with which Ilkley marked the peace celebrations.'

Plans for a permanent memorial to the Ilkley men who died in the First World War were in hand from 1919. Land at the western end of The Grove on the corner of Bolton Bridge Road was donated by Mr Joseph Cooper to provide grounds for a cenotaph. The cenotaph was designed by Mr J. J. Joass of London. On each of its four sides are bronze tablets with the names of the 183 Ilkley men who gave their lives in the war stood out in relief.

On Sunday 22 July 1922, there was a parade along The Grove to the official unveiling of the cenotaph. The ceremony was performed by Captain Harold Maufe VC. The procession started near the town hall and was headed by the artillery band from Otley. Ex-servicemen attended along with the local Howitzer Battery, as well as volunteers,

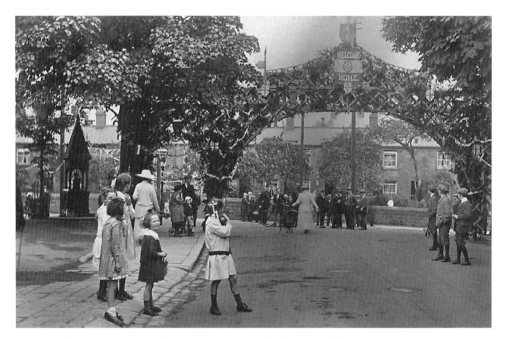

Peace celebrations at Burley. An arch was built at the bottom of Station Road, intertwined with Scotch Yew tree branches and decorated with fairy lights. Hanging from the arch was a banner with the message: 'Welcome Home'. The children of ex-servicemen were entertained at tea.

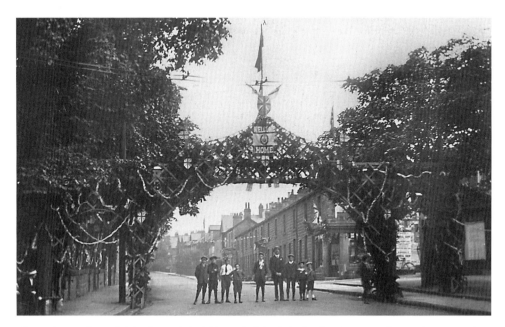

Closer inspection of this view of the Triumphal Arch in Burley in 1919 shows the tram wires running across the street above the arch. The 'trackless tram' service had started in September 1915 and later linked Burley to Guiseley and Leeds, but it was never extended to Ilkley and was withdrawn in the late 1920s.

male and female, from the St John Ambulance companies, Girl Guides and members of the urban council and magistrates. In the memorial ground, the ceremony opened with the singing of the hymn 'O God Our Hope in Ages Past', followed by the reading of a passage of scripture and a prayer. Mr Bray of the War Memorial Committee addressed those present:

> He thought and hoped that it would not be considered an unfitting or an unworthy memorial to those gallant lads of Ilkley who, at their country's call and in the flush of their youth and strength, gave up all, that we might live. Their graves were scattered far and wide, but the memory of their deeds, and their names, abided, and would abide, a sweet recollection to us for all the days that were to come.

The address was followed by a minute of silence, and then an address was given by the Bishop of Bradford on the theme of thankfulness, hopefulness and sacrifice that the cenotaph symbolised. The service concluded with the national anthem, followed by the placing of wreaths at the foot of the memorial by the Ilkley Council and representatives of the local regiments present.

In the years immediately following the war, there were a number of national

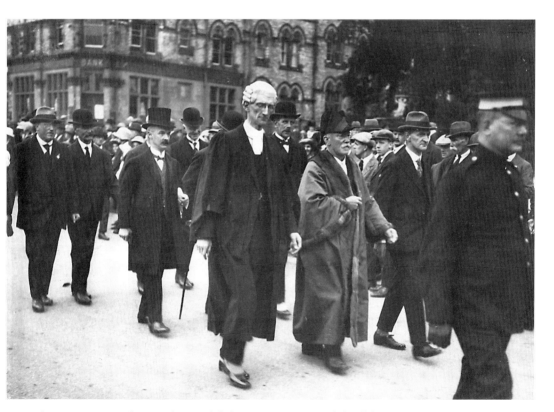

The procession to the unveiling and dedication ceremony of the Ilkley War Memorial proceeds along the top of Brook Street towards The Grove.

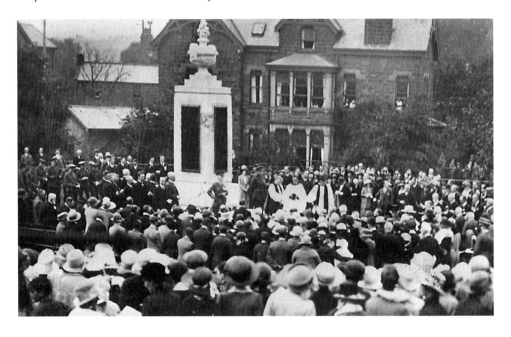

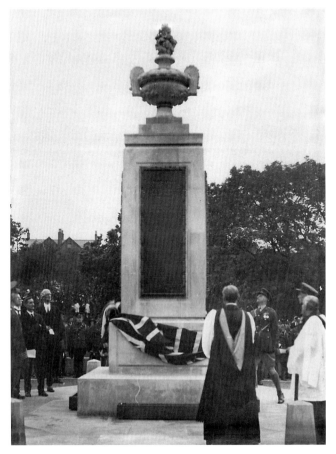

Above: Crowds at the unveiling and dedication of the Ilkley War Memorial, 22 July 1922.

Left: The memorial is dedicated by the Bishop of Bradford, Mr Perowne.

organisations supporting the welfare of ex-servicemen. Earl Haig was working to amalgamate the various associations into a single organisation – The British Legion. One of these groups was The National Federation of Discharged Sailors and Soldiers. In Ilkley they had established a branch in the Arcade in August 1918, before moving to Tower Buildings at the bottom of Cowpasture Road in May 1919. The club provided Christmas gifts for children of members and local men who had been killed during the war.

A little later in the year it was decided that the club should become the Ilkley branch of the British Legion, officially formed at a meeting held in the council chamber in the town hall on the evening of 15 August 1921. The president was Mr J. W. Dixon, and the British Legion was subsequently based in the Tower Buildings, where it remained until later in the decade. In March 1921, Lt Col. J. Muller had called for the formation of a branch of the Officers Association in Ilkley. This was itself a branch of the British Legion. By 1927, the facilities were inadequate for the needs of the growing club, and in February 1928, they moved to a large house at the top of Mornington Road. In 1949, the club moved again into premises on Wells Road, named Annandale. The building was extended in 1969, and served the club until the 1990s when it was sold for development.

Although the Ilkley Legion had no club premises then, the branch continued with a dwindling membership until 2012. At a meeting at the Riverside Hotel, the four remaining members decided that, due to a lack of sustainable membership, the branch would be amalgamated with the remaining members of the Addingham branch, ending over ninety years presence in Ilkley. In the diaries of the Howitzer unit, published in 1931, Sgt A. E. Gee wrote,

> The great Annual Dinner has proved to be the glorious opportunity for reunion and refreshment, and the renewal of old friendships. Only the nucleus of the men live at Ilkley; others come from far afield to drink the same three toasts year by year: 'The King', 'The Battery,' and 'Absent Friends'. As for those of our comrades who did make the supreme sacrifice, let us think of them as the Yorkshireman, in his toast, speaks of them:

> > 'There's some 'at noan are here lads;
> > Forget 'em we s'all neer lads.
> > Yorkshiremen, they all on 'em wer,
> > Yorkshiremen they all on 'em are.
> > There's threng uns and loan uns,
> > There's wick uns, and goan uns-
> > They're all reet weeriver they are,
> > And we'se be no war.'

> The boys of Ilkley and district have had their great adventure. Like the army of the great soldier, Caesar, they came, saw, and conquered. Finis is written to stirring days, and the threads of civilian life are gathered up again. That their shadows may never grow less, and their tankards never be empty, is the sincere wish of 'A Gunner'.

Burley War Memorial, outside Burley Grange, was first dedicated in May 1923.

The cenotaph grounds at the corner of The Grove and Bolton Bridge Road. The cenotaph is over 19 feet high and is made of Portland stone. On each of the four sides are bronze tablets bearing the names of the 183 Ilkley men who gave their lives in the war.

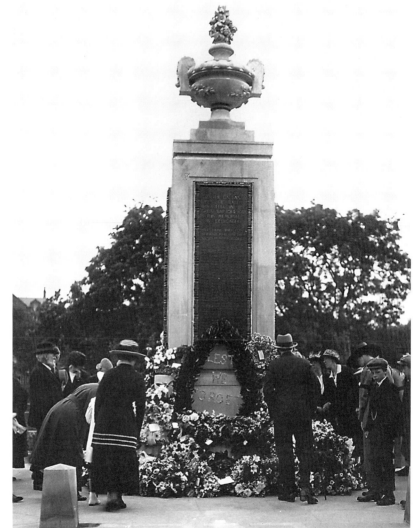

In November 1922, the Armistice Day commemorations were markd at the cenotaph with a solemn service, followed by wreath laying by civic, religious and military organisations. This tradition has remained unbroken, even during the dark days of the Second World War, and continues today.

BIBLIOGRAPHY

Cockshott, Alex and Denise Shillitoe, *Ilkley Past and Present* (Sutton, 2005).

Dixon, Mike, *Images of England: Ilkley* (Tempus, 1999).

Gee, A. E. and Shaw, *A Record of D245 Battery: 1914–1919* (London: Renwick of Otley, 1931).

Liddle, Peter, *Voices of War* (Avon: The Bath Press).

Magnus, Laurie, *The West Riding Territorials in the Great War* (London: Kegan Paul, 1920).

Salmon, Norman, *Ilkley Grammar School 1607–1957*.

Saywell, John, *A History of the Ilkley Golf Club 1890–1990* (Otley: Smith Settle, 1990).

Scott, W. H. *Leeds in the Great War 1914–1918* (Libraries and Arts Committee, 1923).

Speight, Harry, *Upper Wharfedale* (London: Elliot Stock, 1900).

Tempest, E. V. *History of the Sixth Battalion West Yorkshire Regiment* (Bradford: Percy Lund, Humphries).

Tennant, Norman, *A Saturday Night Soldier's War* (Oxford: The Kylin Press, 1983).

The Olicanian, 1914–1921.

Wood, Peter, *Olicana's Children* (Ilkley Grammar School, 2009).

Yorkshire Rugby Football Club, *Commemoration Book 1914–1919*.

ILLUSTRATION SOURCES

Bradford Libraries pages: 35, 39 (bottom image), 57, 58 (bottom image), 53, 57, 58 (bottom image), 60, 65, 123, 124.

Sally Gunton pages: 10, 12, 14, 17, 18, 19, 29, 30, 36, 37, 38, 39 (top image), 40, 41, 43, 44, 45, 46, 47, 48, 50 (bottom image), 51 (top image), 52, 56, 58 (top image), 63, 66, 68, 69, 72, 73 (top image), 75 (top image), 78, 81, 88, 95, 96, 99, 120, 121, 122, 126, 127.

Mark Hunnebell page: 94.

The *Ilkley Gazette* pages: 16, 83, 100.

Liddle Collection, Brotherton Library, Leeds University pages: 20, 24, 25.

West Yorkshire Archive Service, Bradford page: 42.